TANGLED TRAVELS

52 Drawings to Finish and Color

BY JANE MONK

Author of the International
Best-Selling Tangled Art Series

Creative Publishing
international

CONTENTS

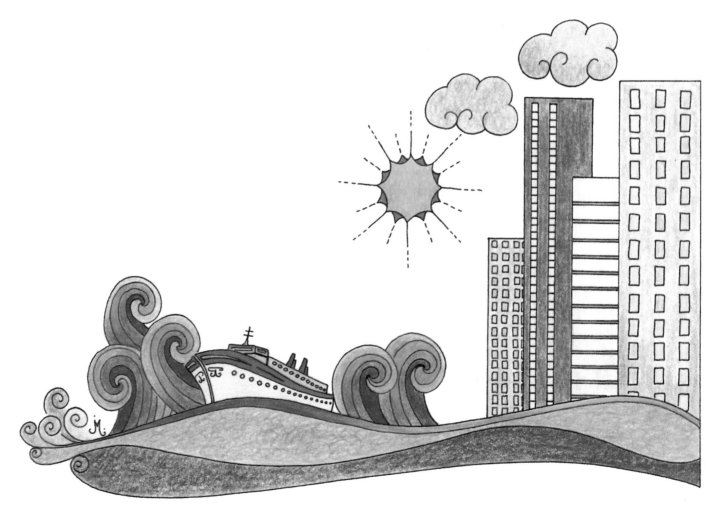

INTRODUCTION

Coloring can take over little pockets of time on a daily basis and we start looking forward to that time we can spend coloring and the activities that go with it. We might collect coloring books, colored pencils, markers, storage containers, and even drawing tables. We enjoy coloring with family, have get-togethers with friends, or simply quiet time by ourselves as relaxation. Our skills are improving; we learn how to shade, to mix color, and color those backgrounds to complement the illustrations. You might ask, where to next?

This third coloring book in my Tangled series is all about travelling, places you might like to visit, and places you may have been before. I am going to show you how you can interact with my illustrations and make your own unique piece of art. I am going to show you how to draw some tangle patterns, background fillers, and what I call "color rests" to make your coloring much more enjoyable.

It is absolutely fine if you have not had much experience with drawing. I often hear people say they can't draw or their hand is a bit wobbly. When you draw, it is like your handwriting; it will look perfectly in place once the illustration has been completed because that wobbly style will be consistent across the whole piece of work. In effect, you have put your unique stamp on it.

Once again all of my illustrations have been hand drawn using a simple fine point black ink pen on paper. I have used my own freestyle drawings and tangle patterns together with Zentangle® patterns, combining them to create a fresh approach to coloring for everyone. You will find a section at the back for testing color combinations and techniques as well as practicing some of the tangle patterns I have shown you how to draw. Or simply go straight to the 52 illustrations and interactive drawings. Use colored pencils, watercolor paint, ink, markers, or any coloring medium you choose. Most of all, have fun.

BASIC SHAPES AND LINES

When we draw, we use just a few basic marks: a straight line, a curve or s shape, and a dot. We use these basic marks to make basic shapes such as circles, squares, triangles, and other forms of these shapes. They really are the basic building blocks of all our drawing needs.

Basic shapes and lines are all we need to draw simple images. For example, a bird can be drawn with a circle for the head, another for the body, and triangles for the beak and wings. A building can be as simple as a rectangle shape or more complex with a mixture of shapes, as with a castle that might have triangles on top of rectangles to make turrets and towers, triangles for the flags, and so on.

Adding your own drawings to the illustrations in this book can be as simple as drawing a few lines and circles and then building on those basic shapes and lines.

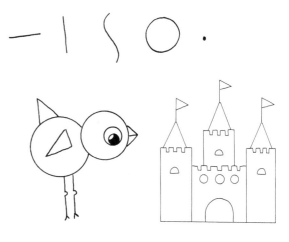

Bird drawn with circles and triangles

Castle drawn with basic shapes

BUILDING UP PATTERNS—VALUE ADDING

Building up patterns is value adding to a basic shape. It can be as simple as repeating the same lines or circles, or more complex as you add more shapes and lines to the base pattern. You can see the progression as I add more lines and more repeats of the same patterns in the illustrations at right.

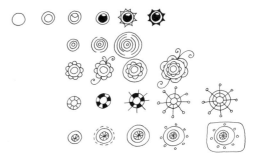

Building up patterns from basic shapes

Adding a simple straight line as a stem to all of these patterns turns them into flowers.

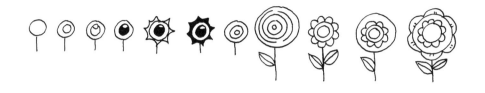

Add even more value by stacking the patterns, placing one behind another or underneath, and providing spaces to add shading and color so as to create depth and dimension to the final illustration.

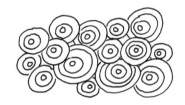

Stacked patterns

Patterns placed behind one another

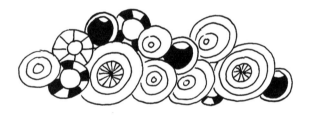

Combining similar shaped patterns creates visual interest.

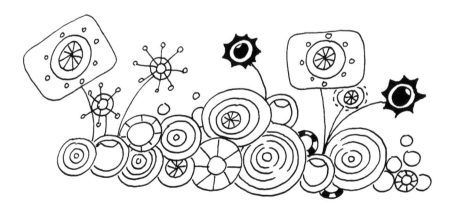

Combining basic circle patterns with flowers creates a story.

What if we do the same thing but use a different shape? Let's try using half circles.

 Single half circle

 Multiple half circles

 Stacked half circles

 Overlapping half circles stacked

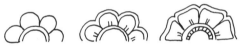
Upside down half circles make waves

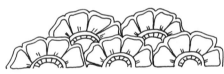
Randomly sized half circles stacked

What if we change the shape of the base pattern and then add some more patterns to add value?

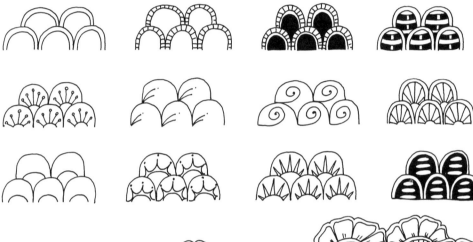

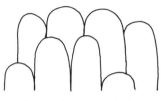

Different styles of patterns built on the basic half circle shape

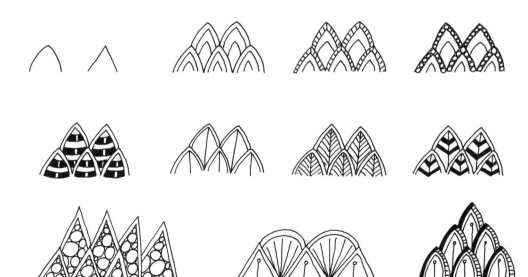

Different styles of patterns built on a more pointed form of the half circle shape

What if we put the shapes between sets of parallel lines and add some lines and circles to the background areas?

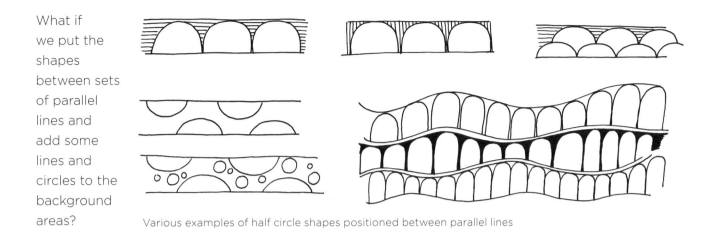

Various examples of half circle shapes positioned between parallel lines

The possibilities are endless. Take some time to explore different shapes and combinations. You will be surprised with the different design combinations you can come up with.

VISUAL SURFACE TEXTURES

Adding visual surface textures to sections of your drawing creates dimension and depth. The simple addition of patterns to create the illusion of texture can make a two dimensional flat drawing look three dimensional.

Surface texture can be as varied as the surfaces you wish to cover. Sky, sea, land, hills, walls, meadows, beaches, and so on. Here are some images of visual surface textures I like to use.

Bark pattern

Wall pattern

Pebble pattern

Grass pattern

Cloud pattern

Scales pattern

Waves pattern

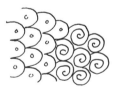

Feather pattern

Dashed line pattern

FRACTALS

A fractal is a never ending pattern, a geometric construction that is self-similar and self-repeating. It looks almost or exactly the same no matter what size it is viewed at. Fractals are used in architecture and design, and of course fractals abound in nature.

I love to use the concept of fractals when drawing tangle patterns. You can create tree shapes by using the self-repeating concept to draw the trunk and then the individual branches as they get smaller and smaller.

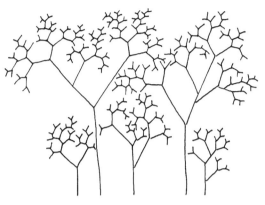

Fractal trees

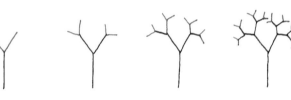

How to draw a fractal tree

I want to tell you about the Apollonian gasket. It is named after Greek mathematician Apollonius of Perga. It is a fractal that is generated from triples of circles where each circle is a tangent to the other two. Basically this means one large circle is filled with three smaller circles and the spaces created are similarly filled with progressively smaller circles. I am no mathematician, but I love the sense of order that can be achieved using this method of filling in space and how loosely the concept can be used without getting stuck by exact measurements. Of course you don't have to use circles to utilize the concept; there is a gasket called the Sierpinski gasket that is based on the shape of an equilateral triangle.

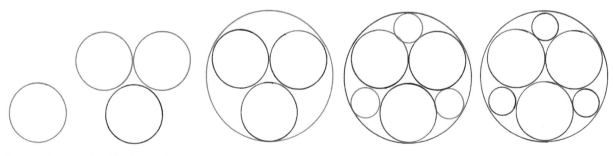

How to draw an Apollonian gasket

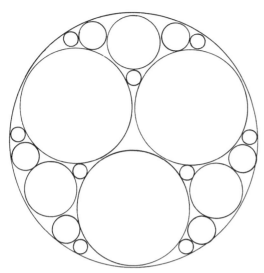

Apollonian gasket

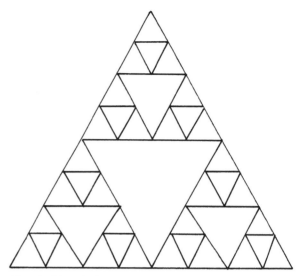

Sierpinski gasket

The concepts of the Apollonian and Sierpinski gaskets are useful as a drawing technique. Without getting too concerned about the perfect shape, you can use the idea by filling the largest area with the largest shape, the next largest area with the next largest shape, and so on. Continue to fill up the spaces with progressively smaller shapes. An unexpected bonus may be that your circles and other shapes will become more smooth and easier for you to draw as you have a confined area to place the shape into.

You can also use these spaces to draw in other motifs such as flowers, as in the example to the right.

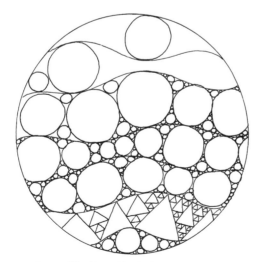

Areas filled in with circles and triangles

Using flowers to fill in circles

COLOR RESTS

Most large expanses of backgrounds occur in illustrations with sky. These areas can be difficult to color without leaving sketchy areas where your coloring lines overlap.

A way to reduce the patchiness and break the large areas of space into smaller and more easily colored areas is to use what I call "color rests." Adding a few small patterns and motifs has the effect of breaking up the space, therefore creating places where you can color within the expanse of the background. This will make any irregularities in your coloring less noticeable.

In a night sky you can use such things as the moon and stars, but how about adding the shape of a constellation or two with some circles? In the day sky you can use the sun, a rainbow, and clouds. If you are not concerned about the realism of your coloring project, you could add random shapes such as circles or flowers. If it is an ocean, you can add waves, sea creatures, or boats. A field or groundscape can have trees, grass, flowers, or any land-based creature or manmade structure added to it.

Coloring without color rests showing sketchy areas where color overlaps.

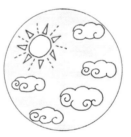

Sky background with color rests added.

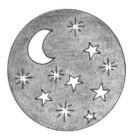

Night sky background with color rests added.

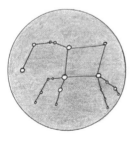

Night sky using the Pegasus constellation as a color rest.

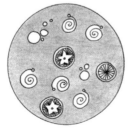

Ocean using swirls and bubbles as color rests.

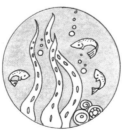

Ocean using fish and reeds as color rests.

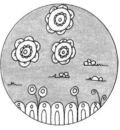

Coloring grass areas without color rests. Notice the sketchy areas where color overlaps.

Grass background with flowers, grass, and a front flower bed used as color rests.

COLORING BACKGROUNDS

I have developed a technique for coloring backgrounds that I call Scrumbling. The final background has a marbled look and it is easily achievable. Choose three shades from the same color family, a light, a mid, and a dark tone. In the example I have used colored pencils from the Faber Castelle Polychromos range. Light Phthalo Blue [9201–145] for the light, Phthalo Blue [9201–110] for the mid-range and Bluish Turquoise [9201–149] for the dark.

Three stages of Scrumbling a background

First Layer: Use the lightest shade of colored pencil. With a light even pressure, use the flat side of the colored pencil in small circular movements until the entire background is lightly covered.

Second Layer: Use the mid-tone shade. With the sharp point of the colored pencil, make small circles and smoothly fill the entire surface. Turn the pencil slightly every so often to help reduce a flat spot. Sharpen your pencil when needed to maintain a sharp point. If you miss a spot, go over it again with overlapping circular movements and a light touch. If you are happy with the finish, you can omit the third layer.

Third Layer: Use the darkest of the three shades of colored pencil you have chosen. Use a sharp point and move the pencil in a scrumble, or scribbly motion across the surface of the paper. You will find the pencil will glide more smoothly than with the previous layers. This is a result of the colored pencil pigment building up on the paper. Continue to create the scrumbled effect on the background until you are happy with the effect.

COLORED BORDERS

Border divided into
uneven boxed shapes

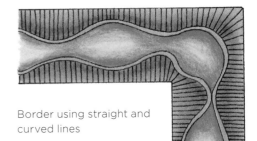

Border using straight and
curved lines

I often like an illustration to have a frame around it. This is easily achieved by using a drawn border. Here are four different border options. Play with the idea using the tangle patterns in the next section and try out your own combinations at the Technique Try Outs section at the back of this book.

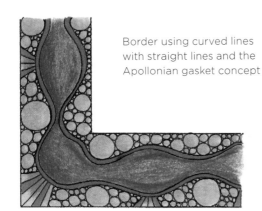

Border using curved lines
with straight lines and the
Apollonian gasket concept

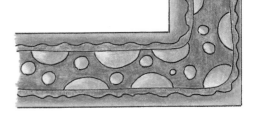

Border using simple
curved lines with
negative space between
center and edges

30 TANGLE PATTERNS

One of my favorite ways of creating backgrounds and building up an illustration is to use tangle patterns. The patterns I have included in this section are easily achievable if you follow each step to create one repetition. Keep repeating the individual steps to create more patterns for a denser look. You can use the patterns as "color rests," include them in border patterns and generally add them to illustrations where you want to. You will also find examples of them used in various ways throughout the 52 coloring pages in Part 2 of this book.

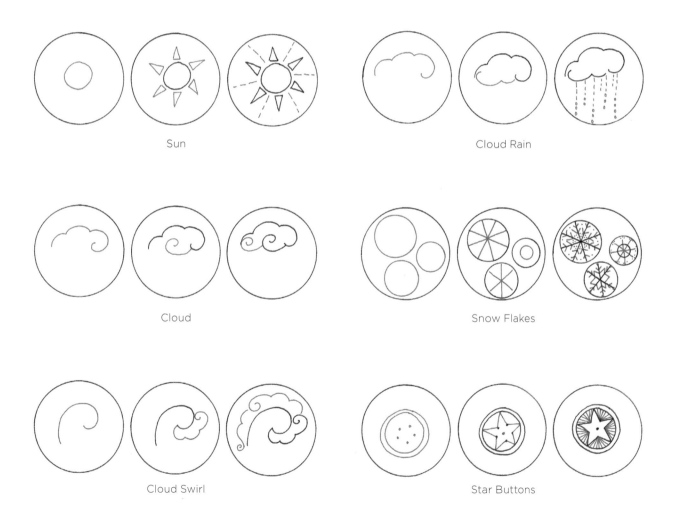

Sun

Cloud Rain

Cloud

Snow Flakes

Cloud Swirl

Star Buttons

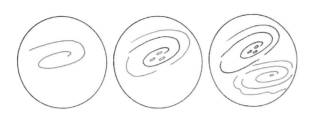

Whirl Pool

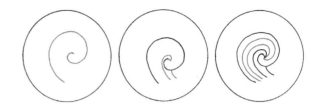

Waves

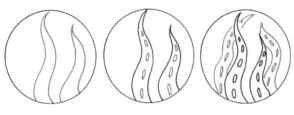

Weedz

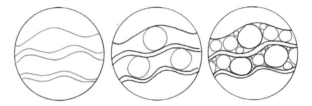

Apollonian Waves

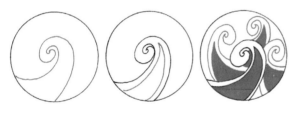

Crescent Wave

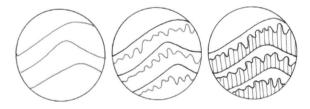

Hillcrest

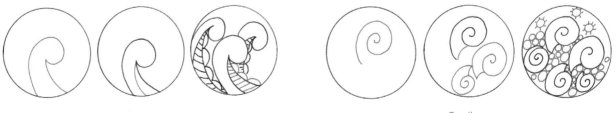

Octo

Snails

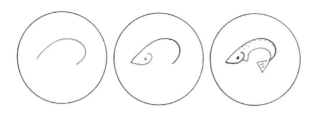

Trout

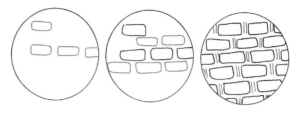

Loave It

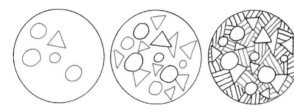

Strata

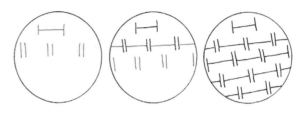

H-Bar

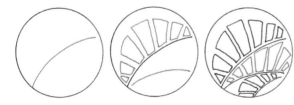

Scapes

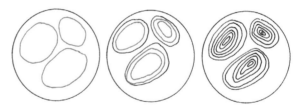

Tree Bones

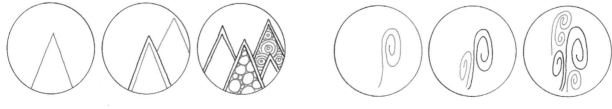

Peeks

Bark

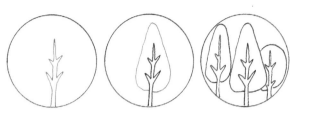

Trees

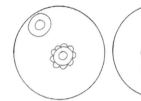
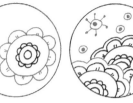

Tortle Flower

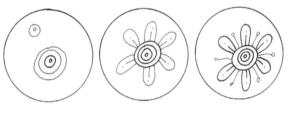

Pin Feathers

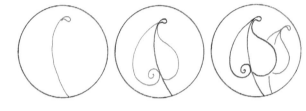

Nouveau

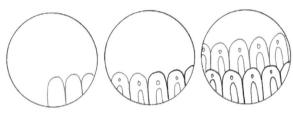

Petal

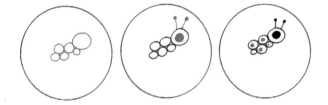

Doodle Bugs

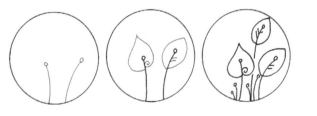

Leaves

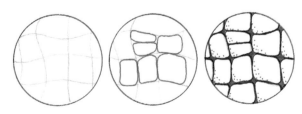

Cobbles (Start with pencil grid.)

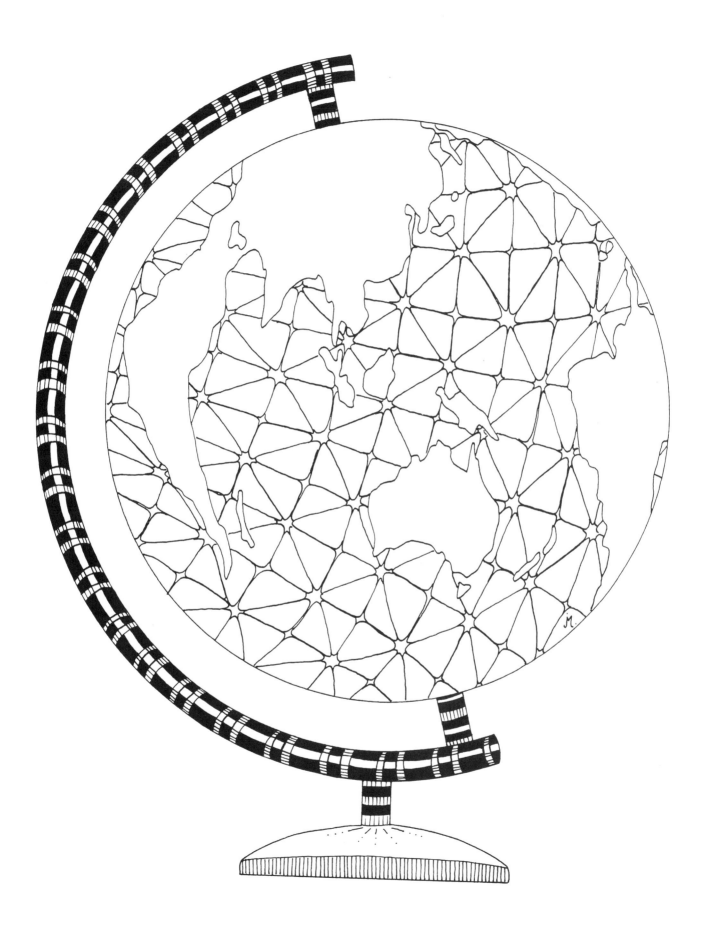

Draw tangle patterns in each box. Refer to 30 Tangle Patterns, page 13.

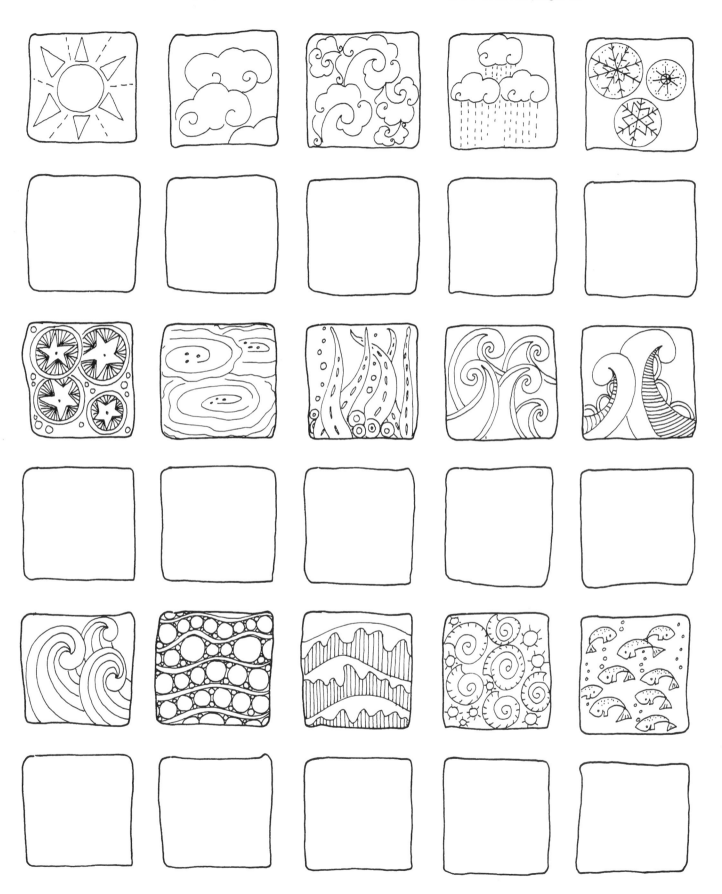

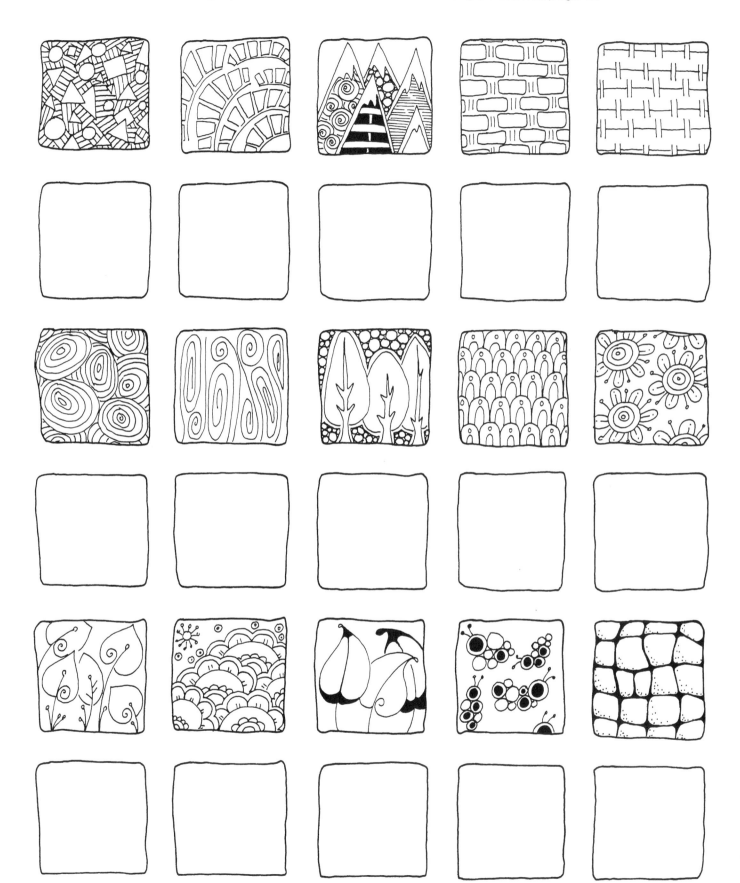

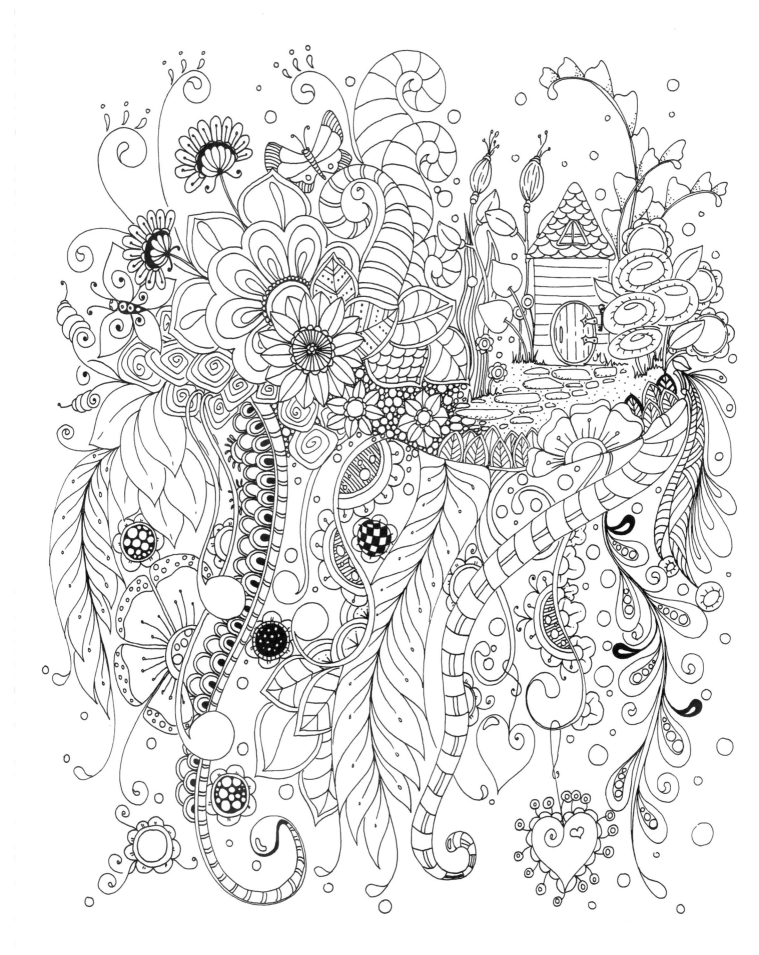

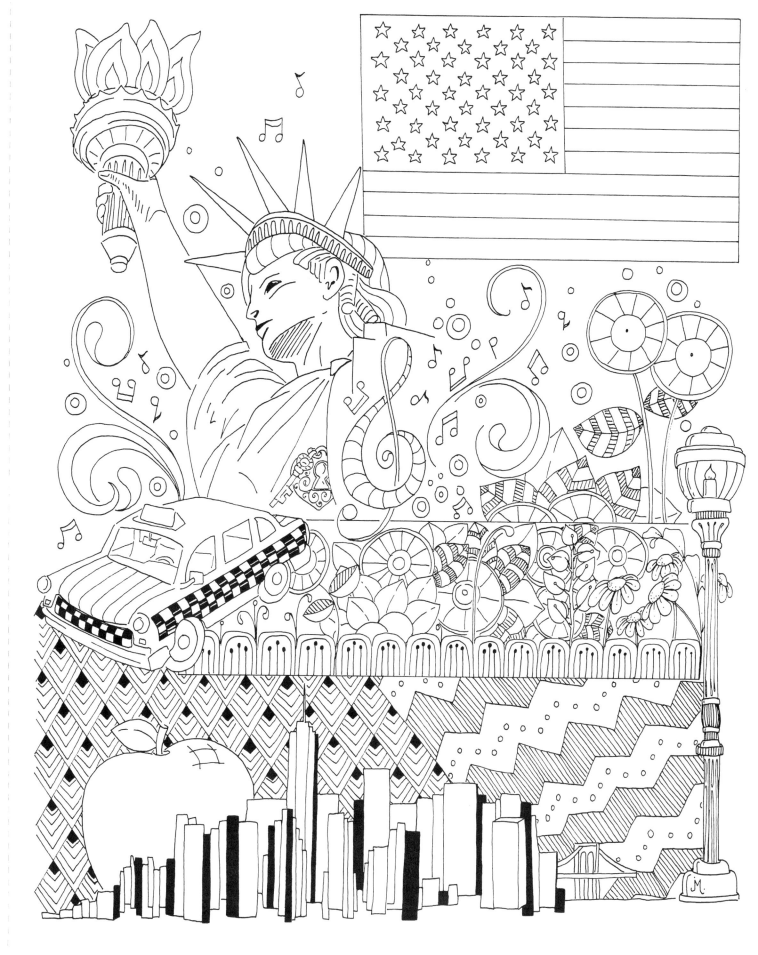

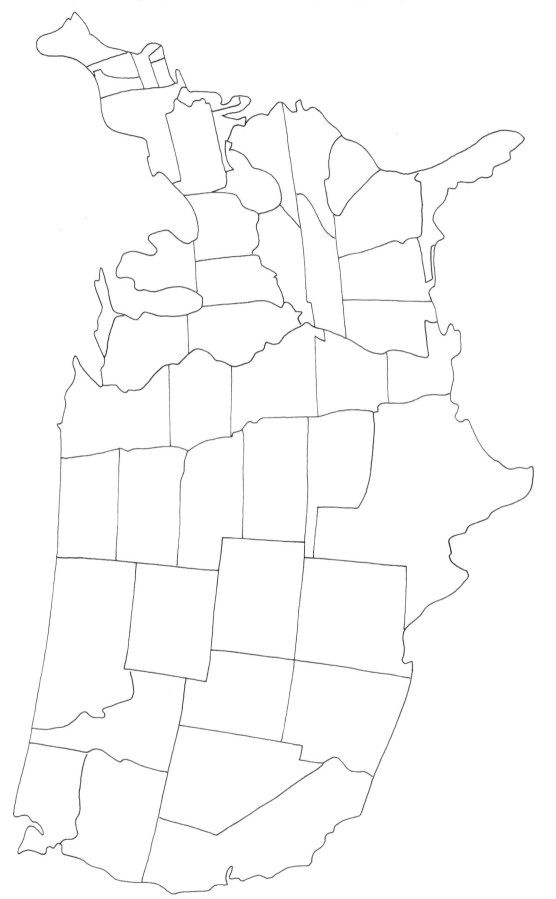

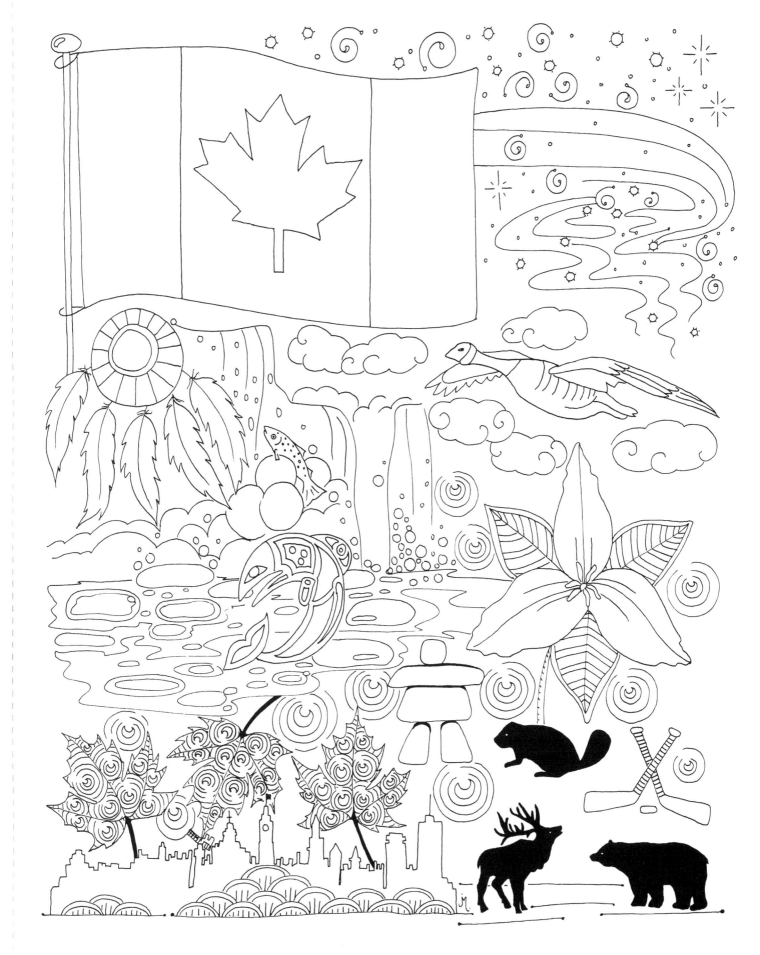

Fill the map with tangle patterns. See the corresponding example inside the front cover.

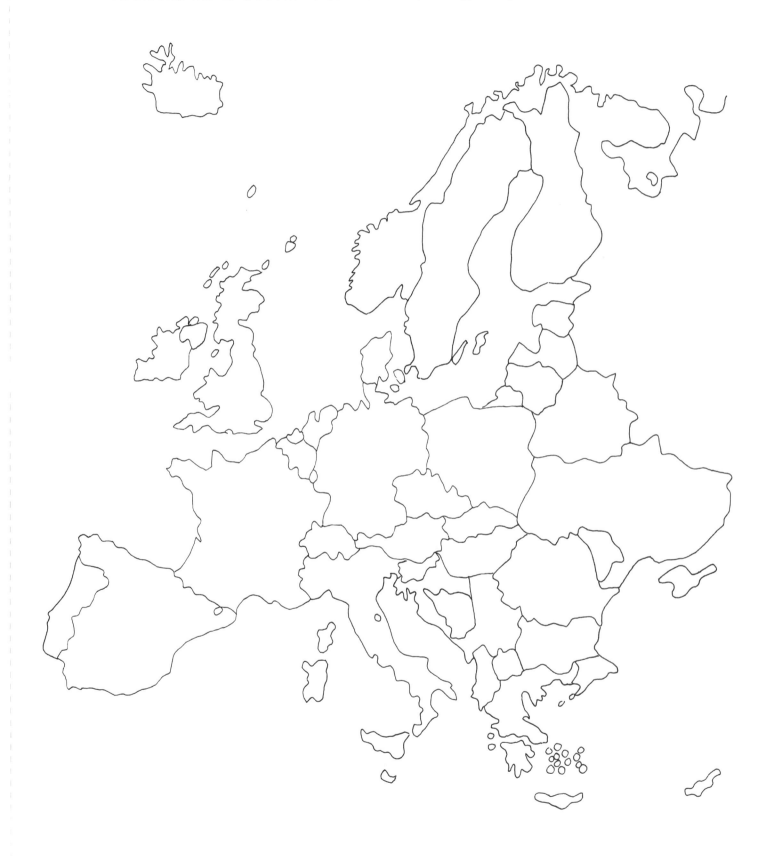

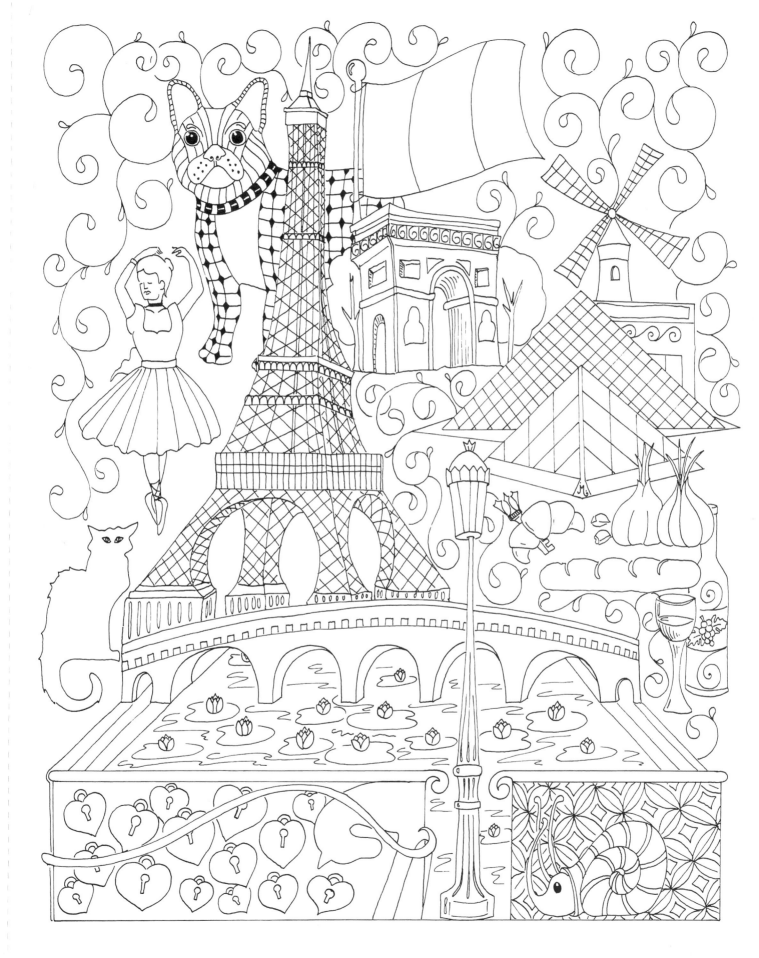

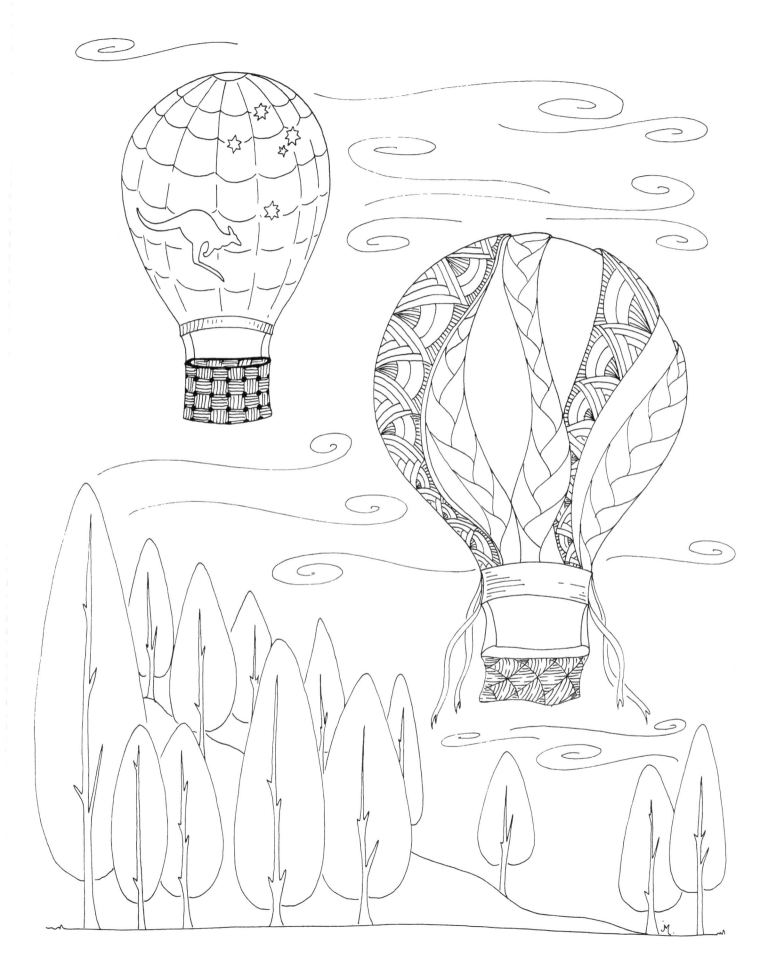

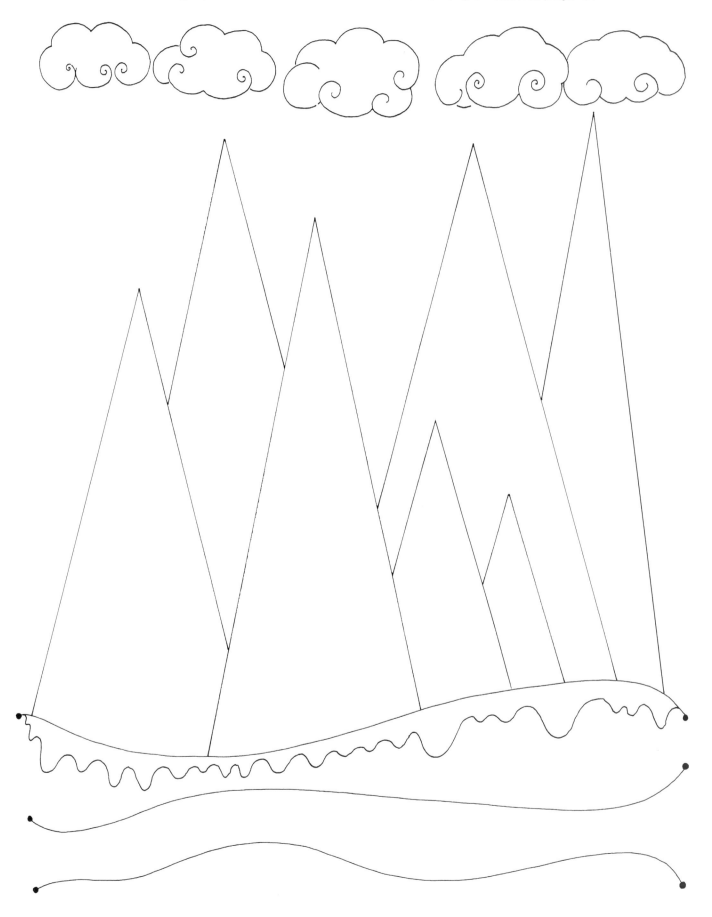

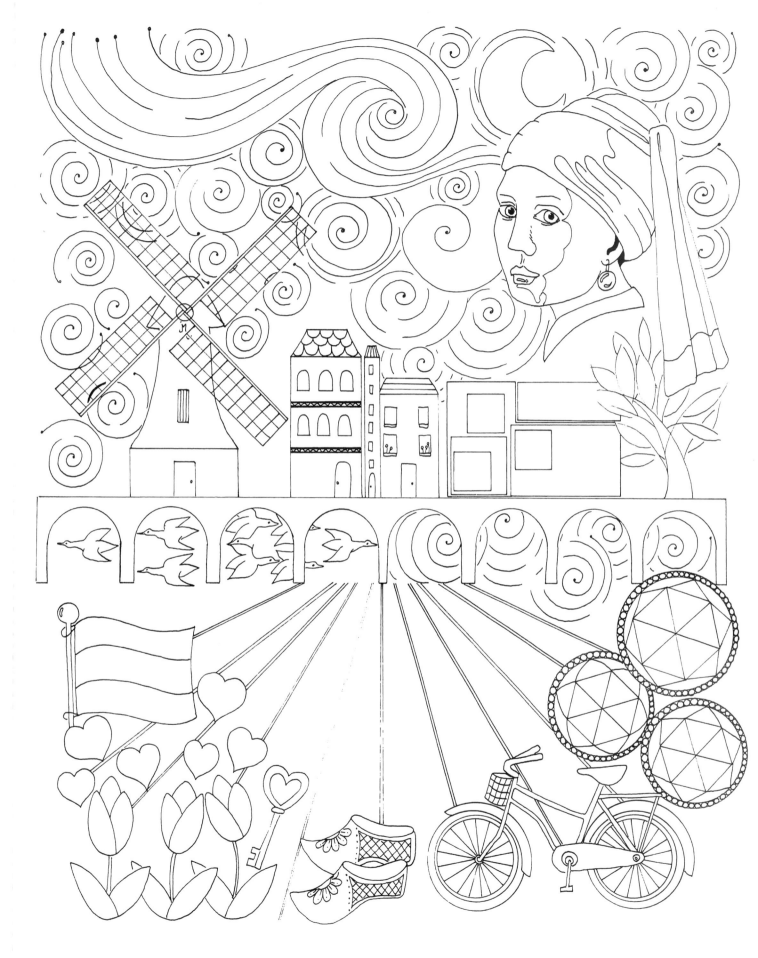

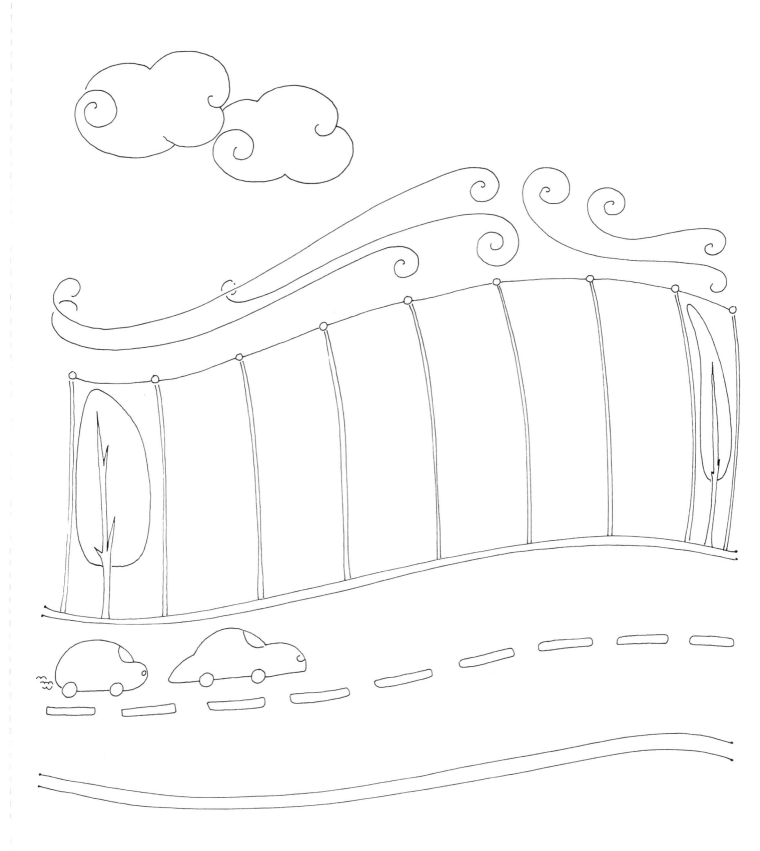

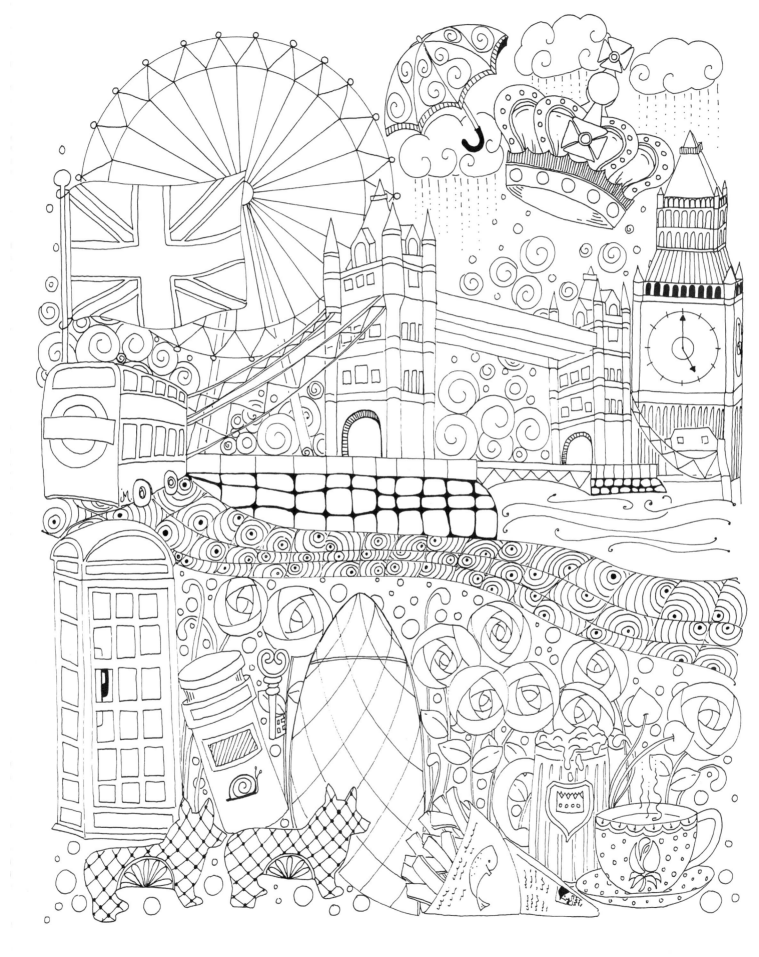

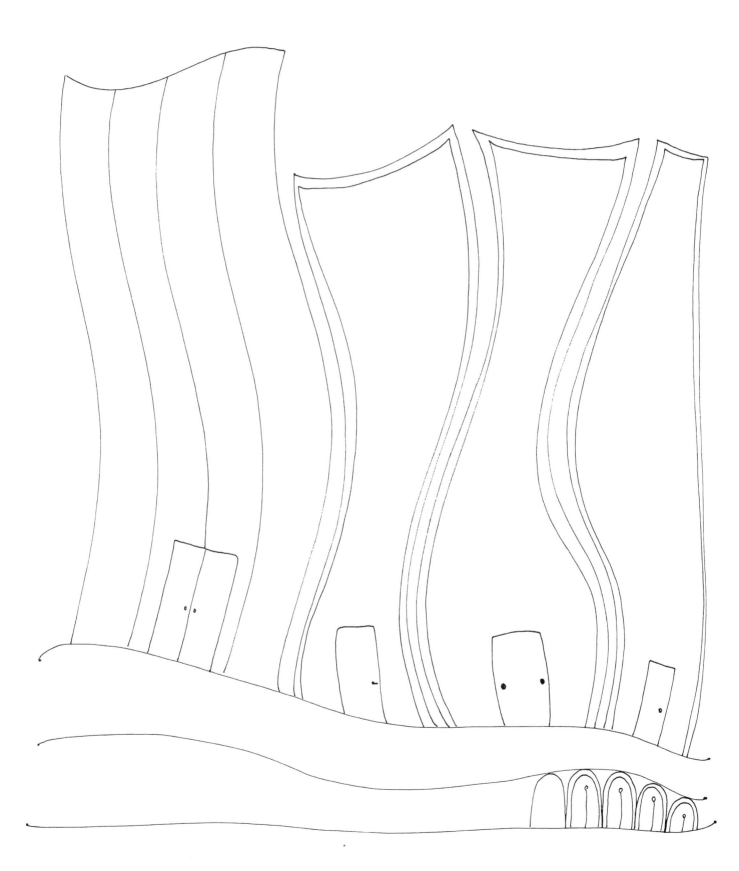

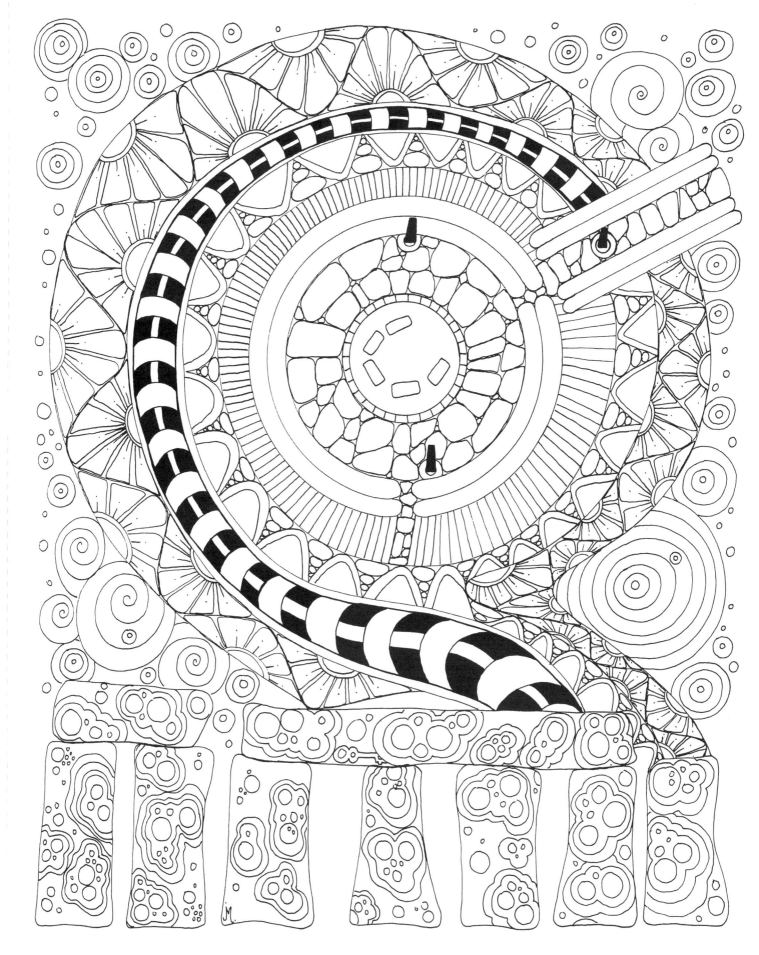

Draw more branches on the fractal trees using the instructions on page 8.

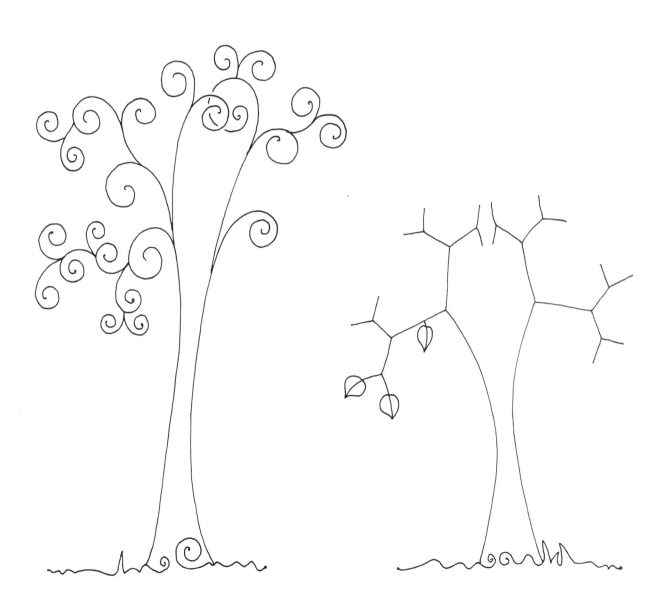

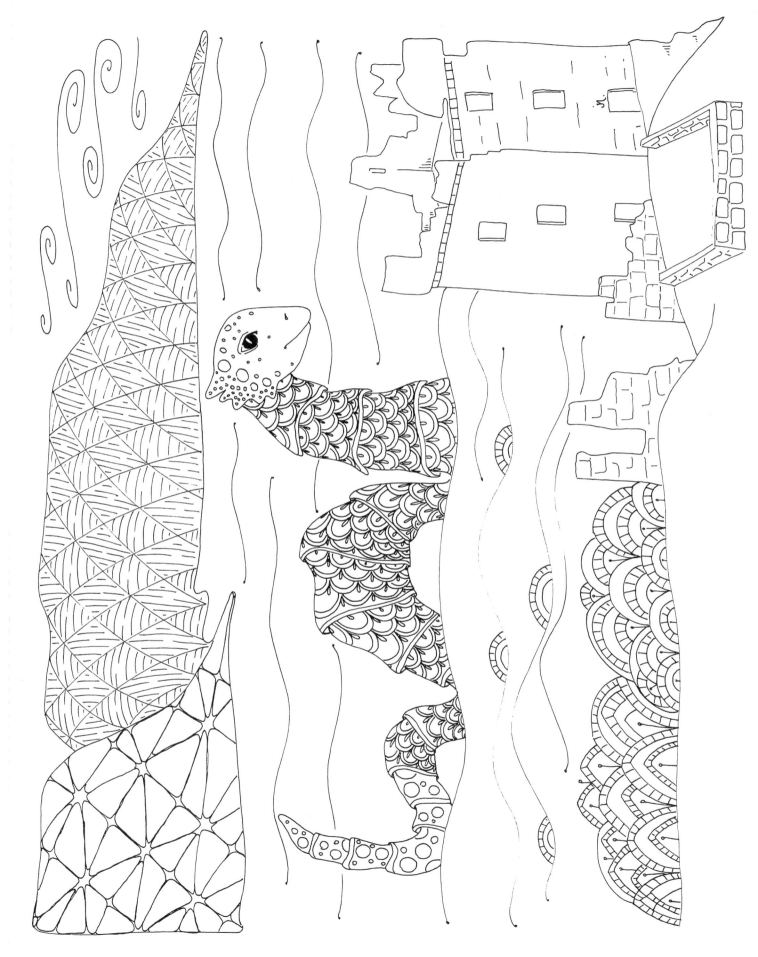

Draw more bricks on the castle walls and fill in the flag. See the corresponding example inside the front cover.

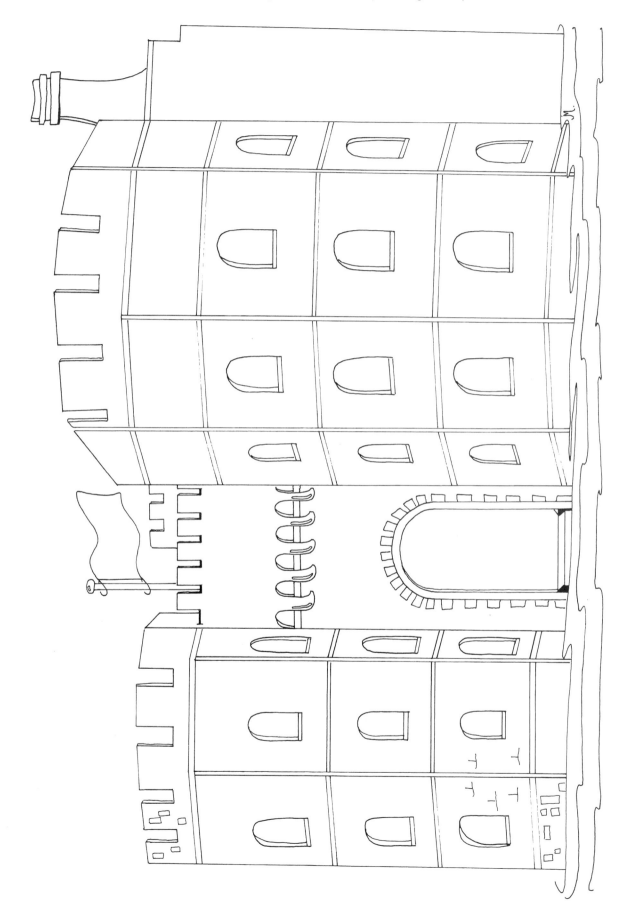

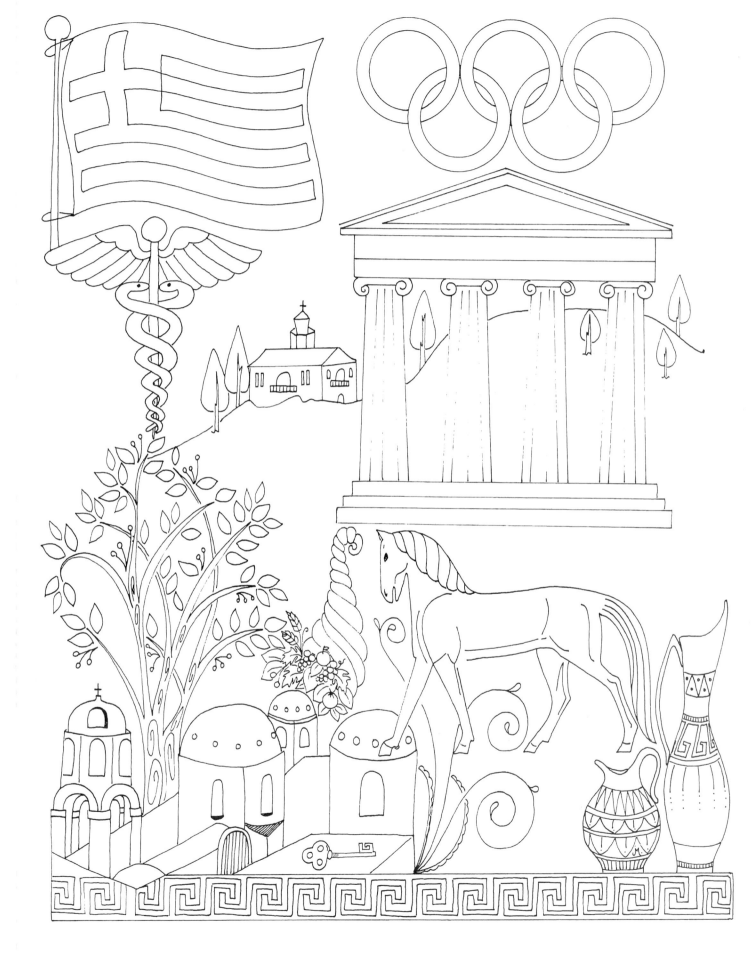

Draw in a tangle Sun (page 13) and write your favorite place names on the signpost.

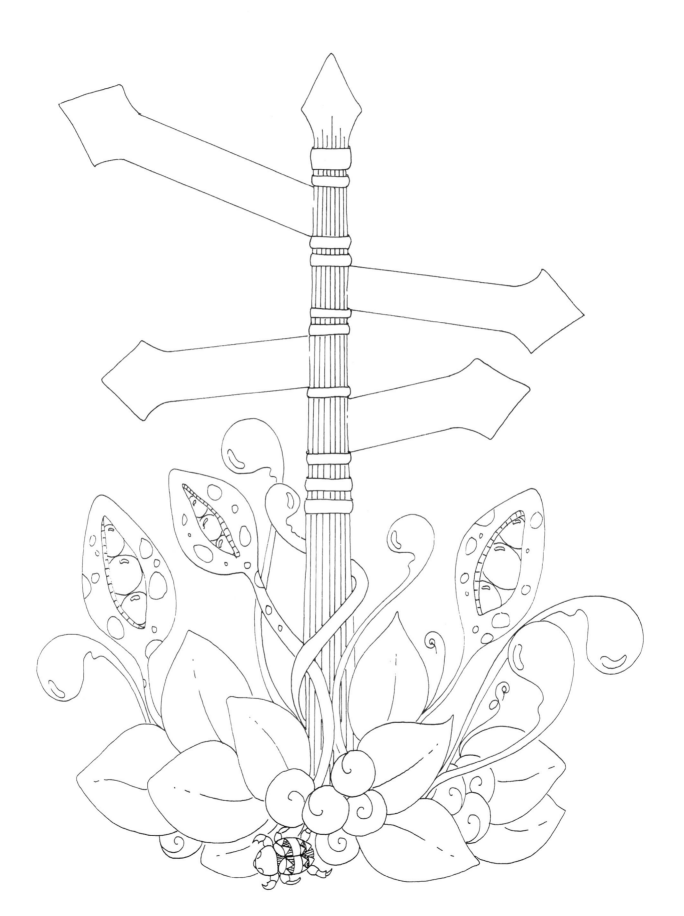

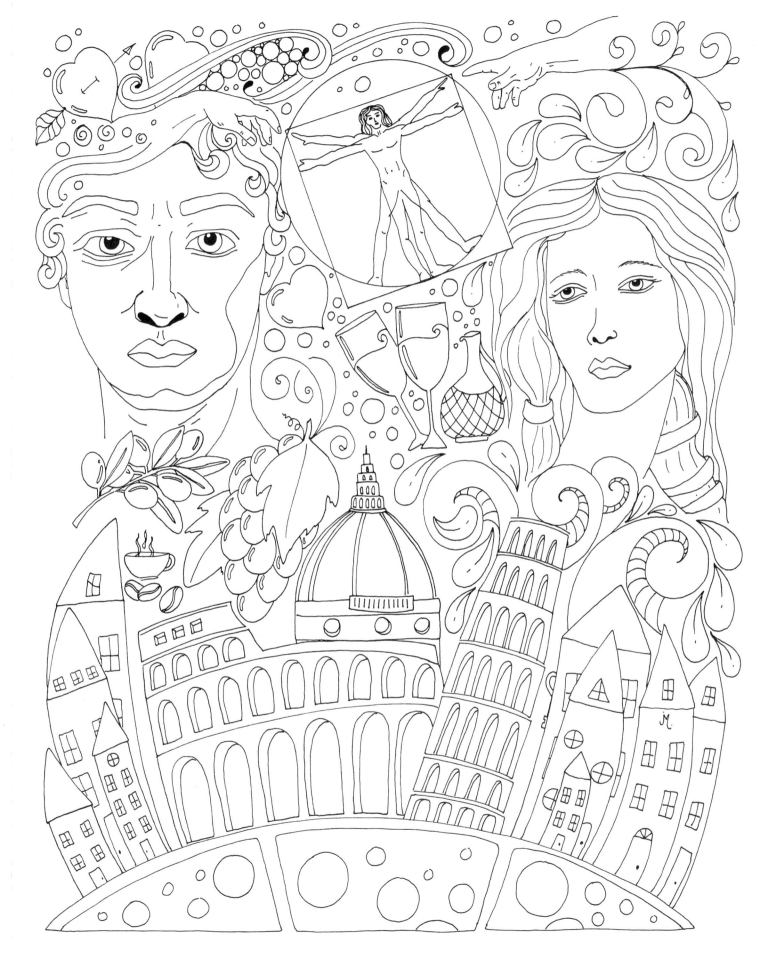

Complete the spaghetti strands and add Star Button tangles (page 13) to the background.

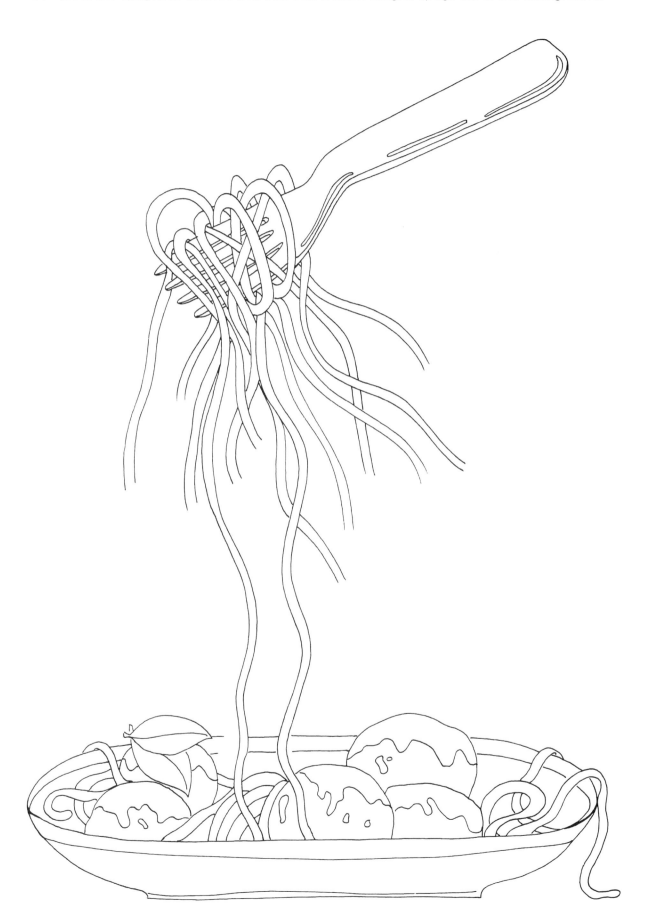

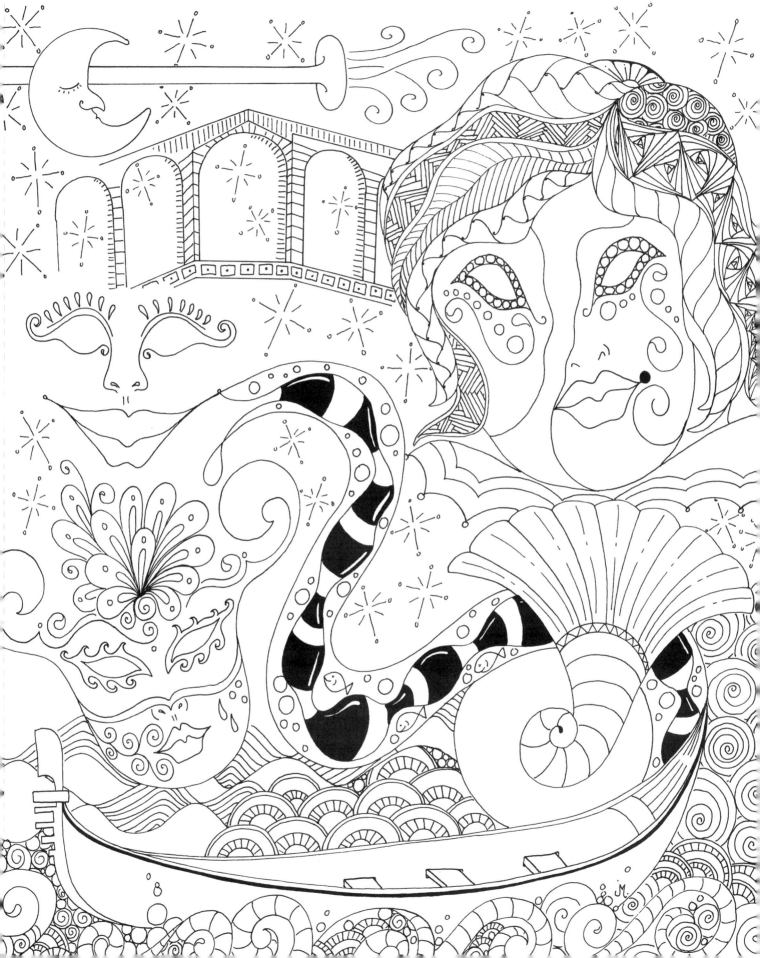

Draw Star Button (page 13) and Petal tangles (page 16) in the background and add stripes to the jester's mask.

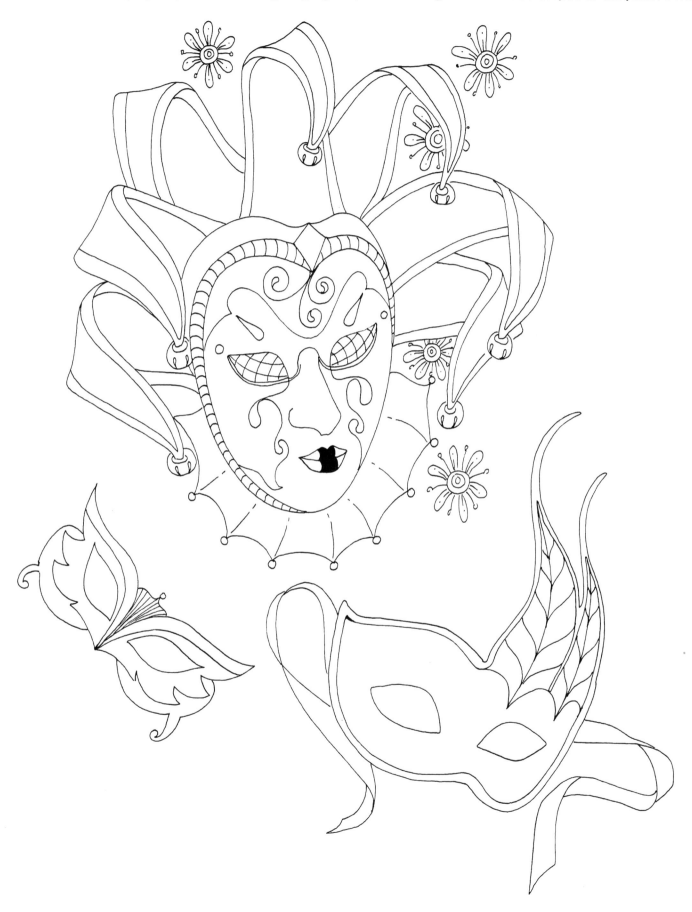

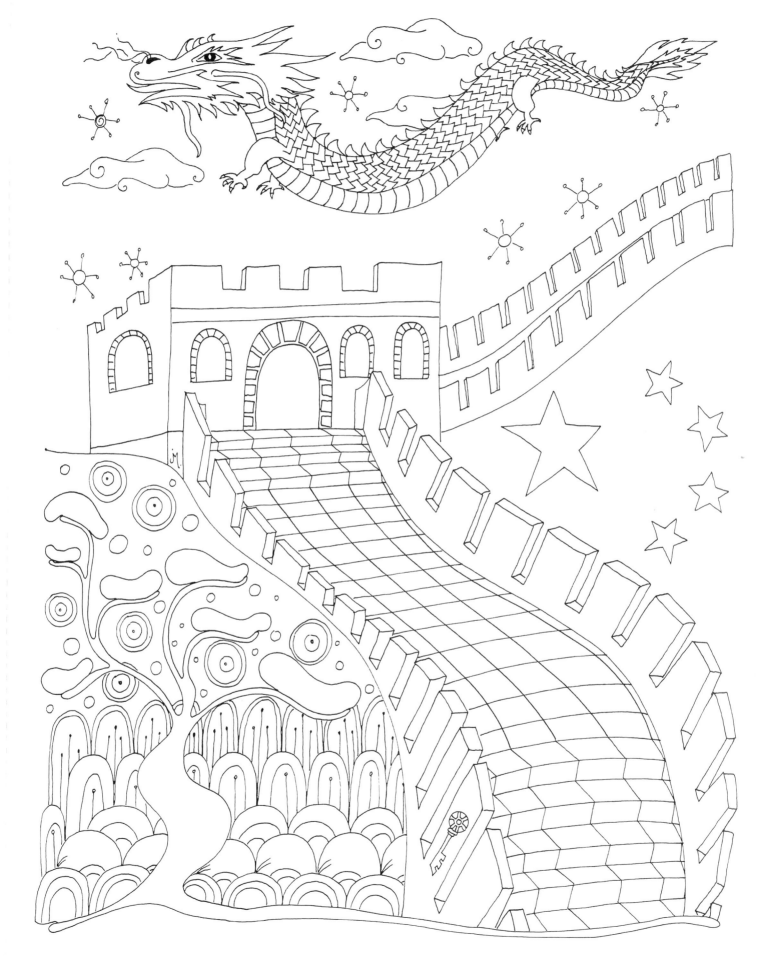

Fill in the mountains, stream, and background. See the corresponding example inside the front cover.

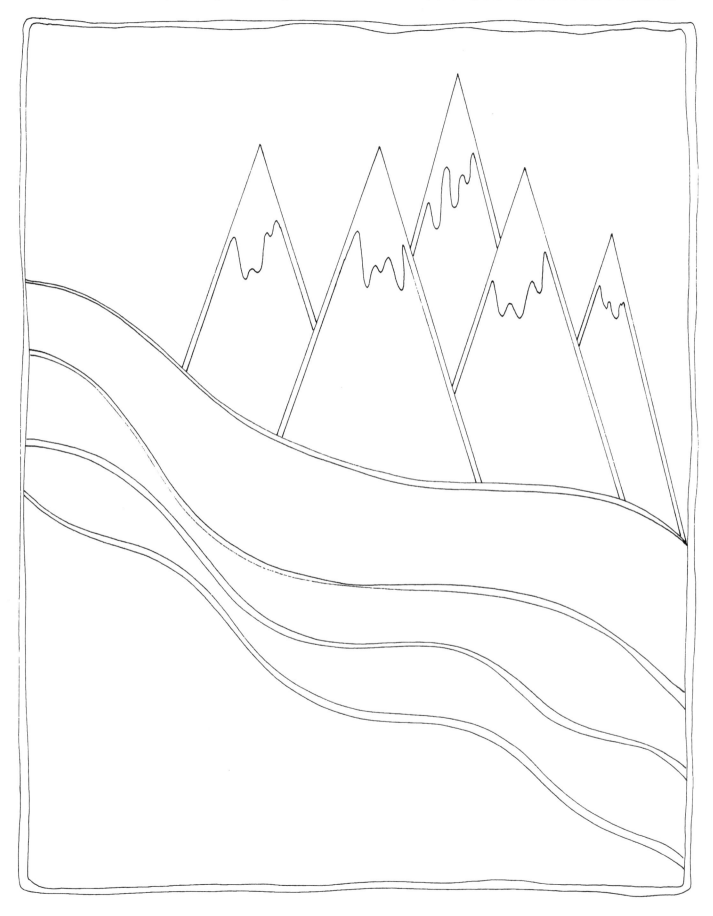

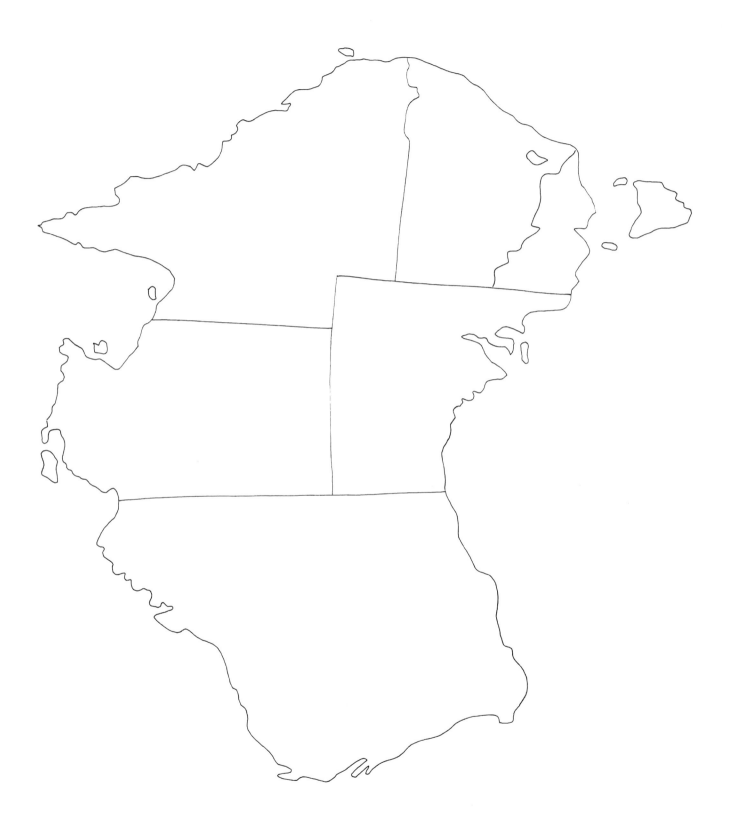

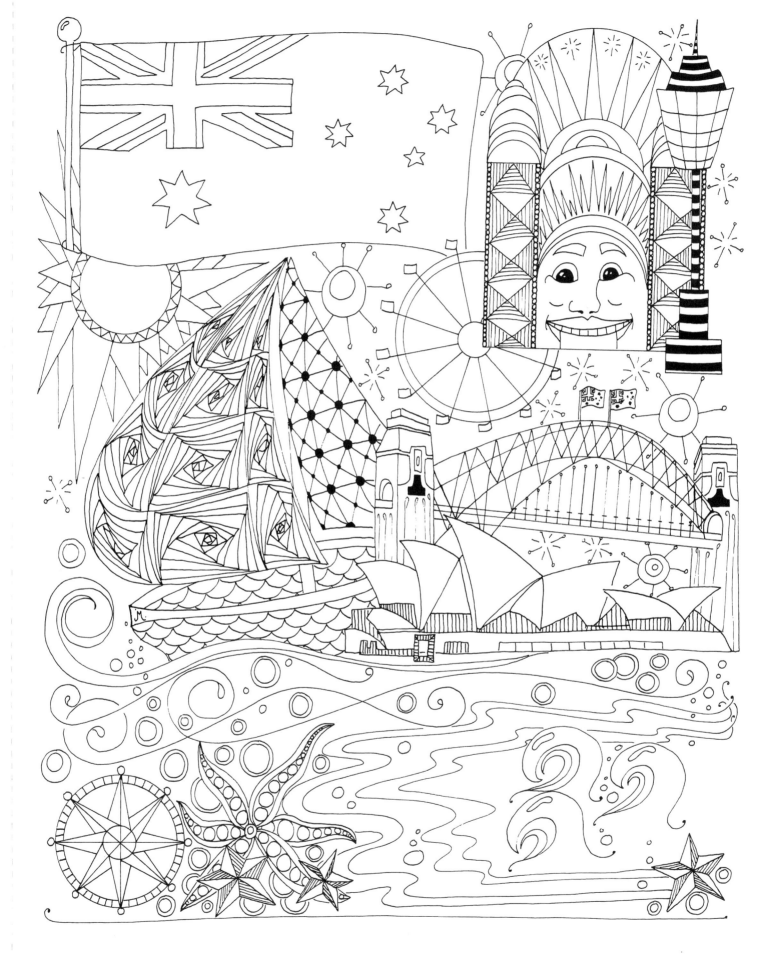

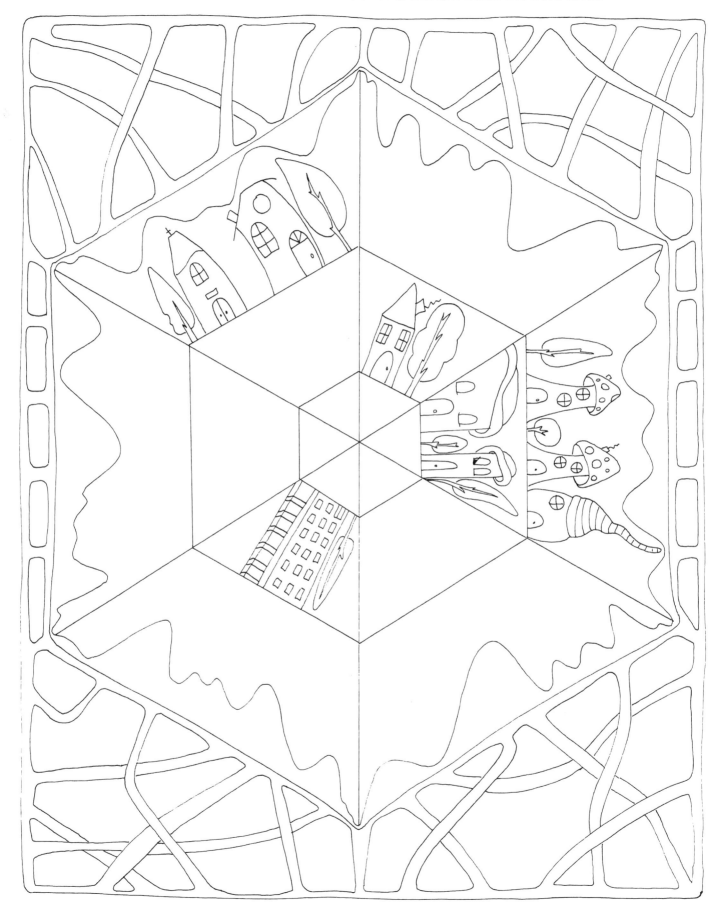

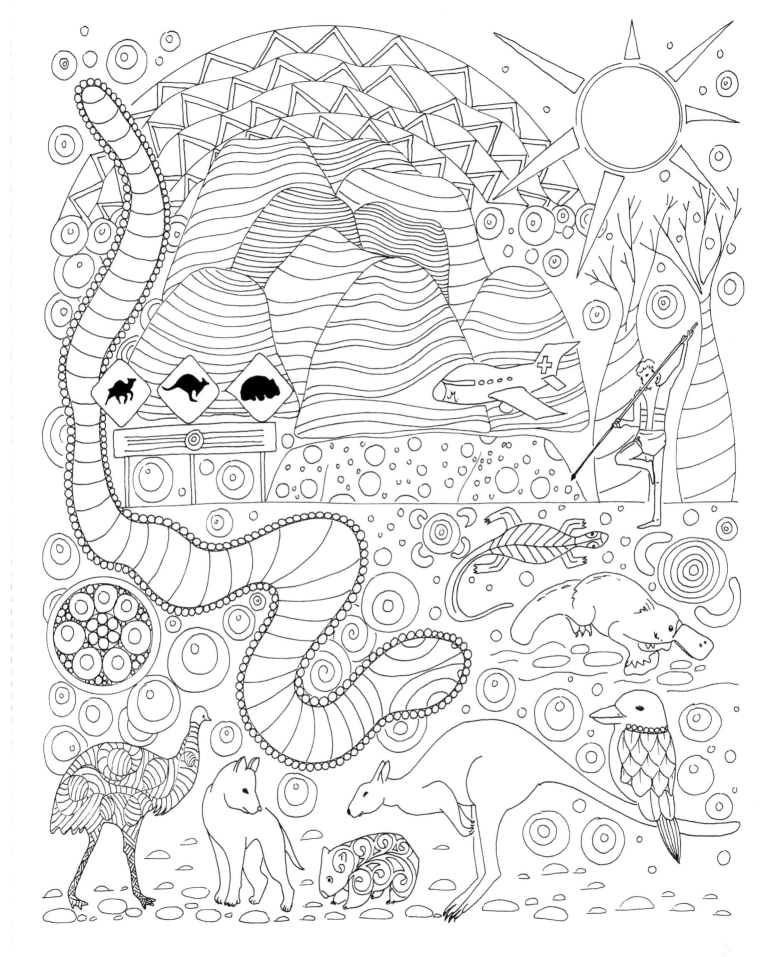

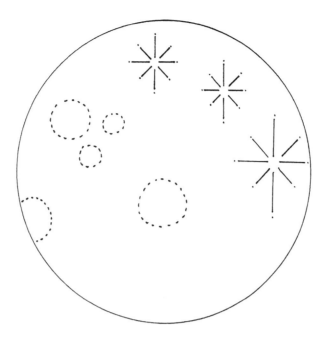
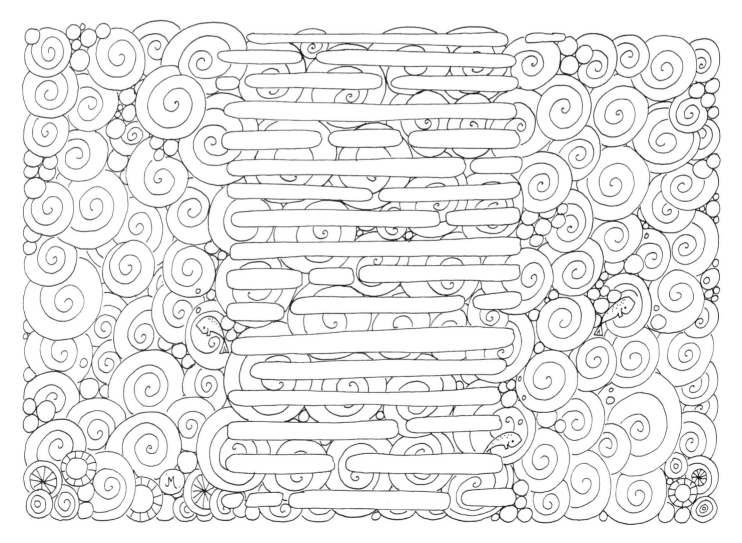

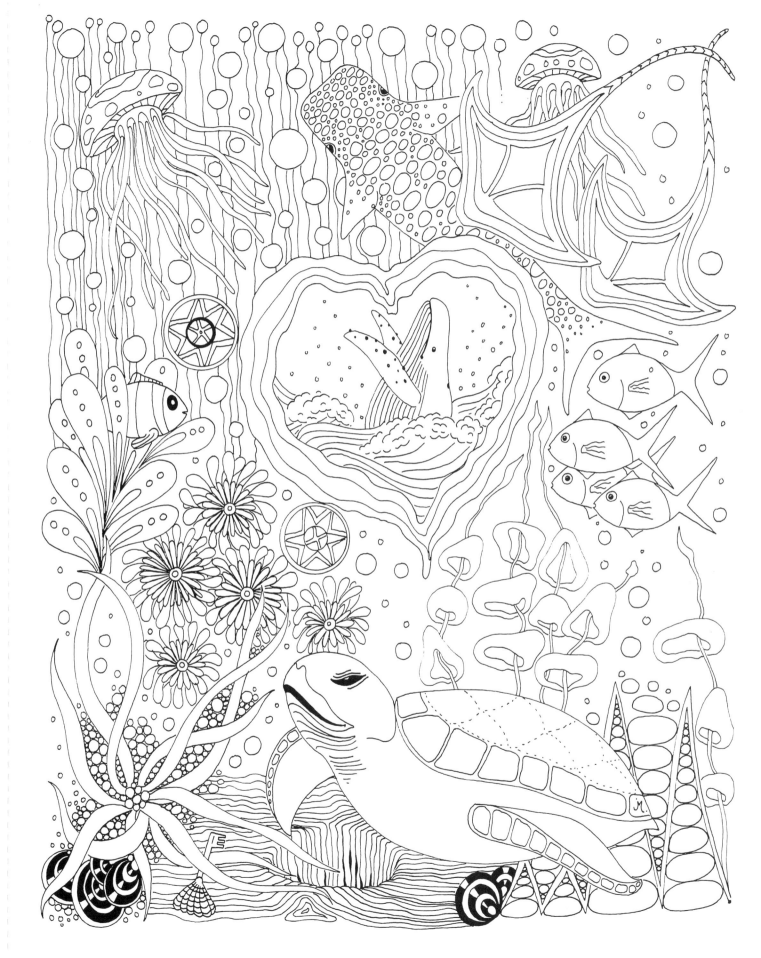

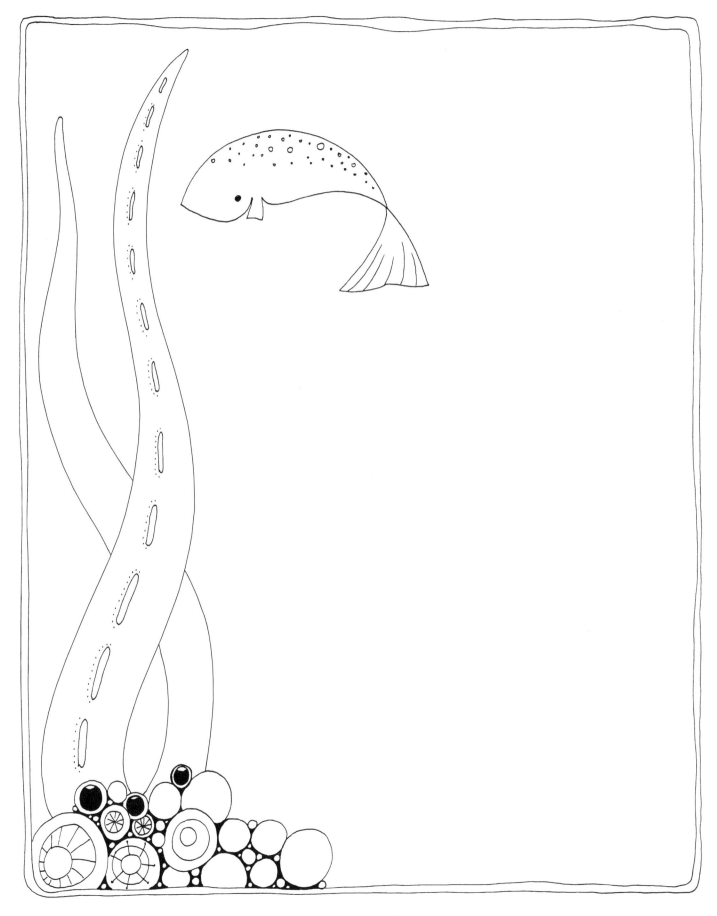

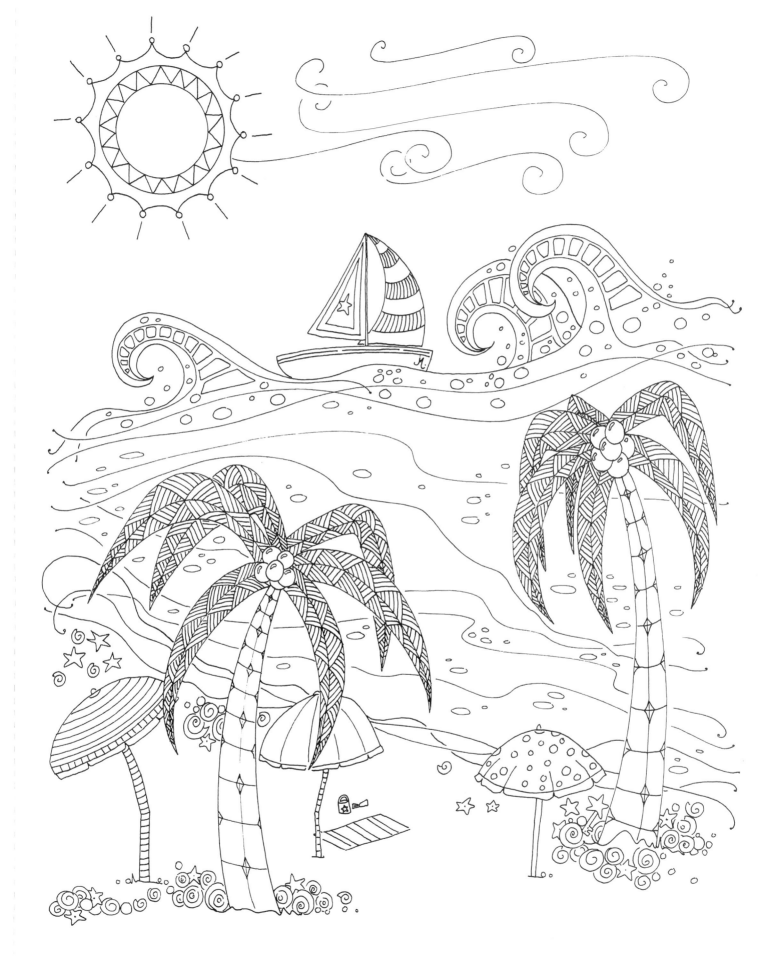

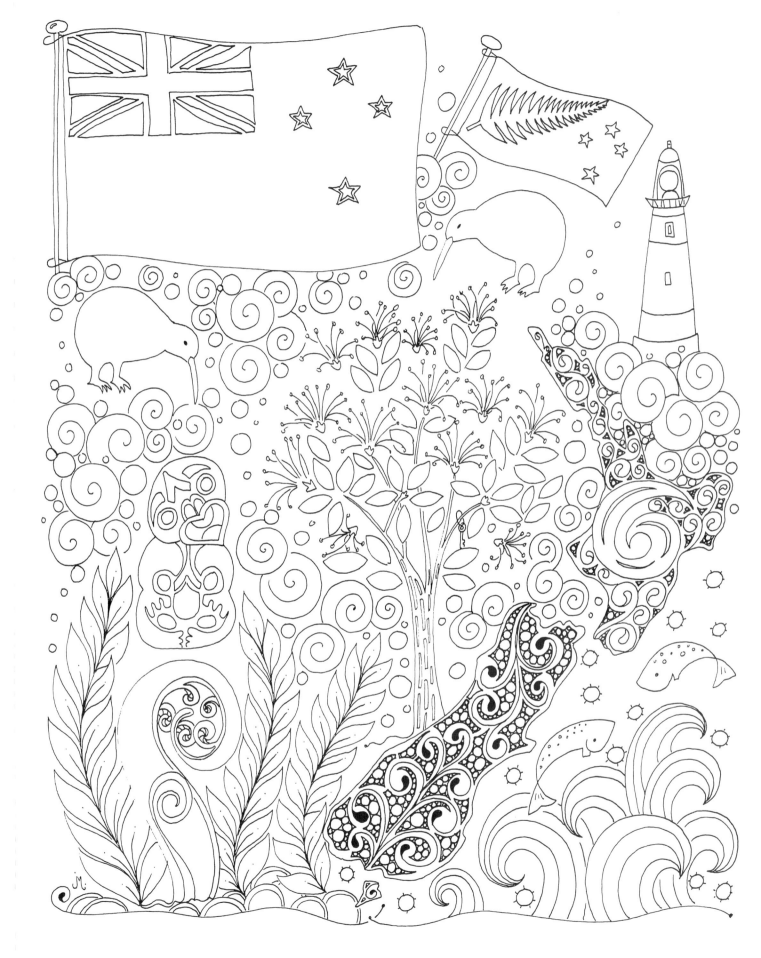

Draw in more Trees (page 16) tangles. See the corresponding example inside the front cover. Add your favorite holiday photo to the center.

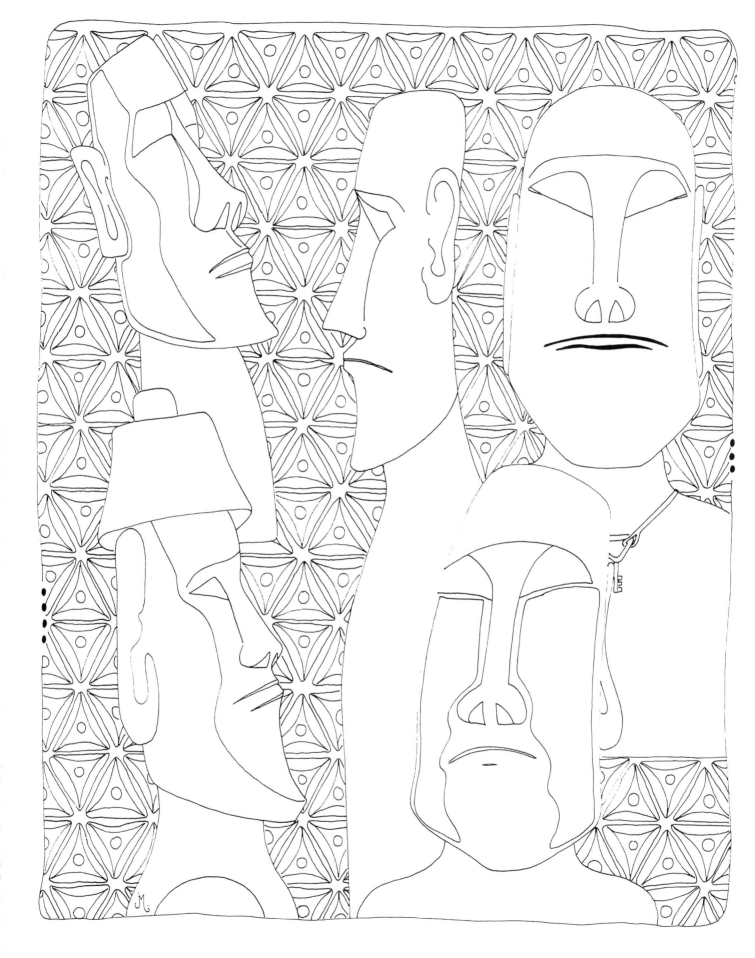

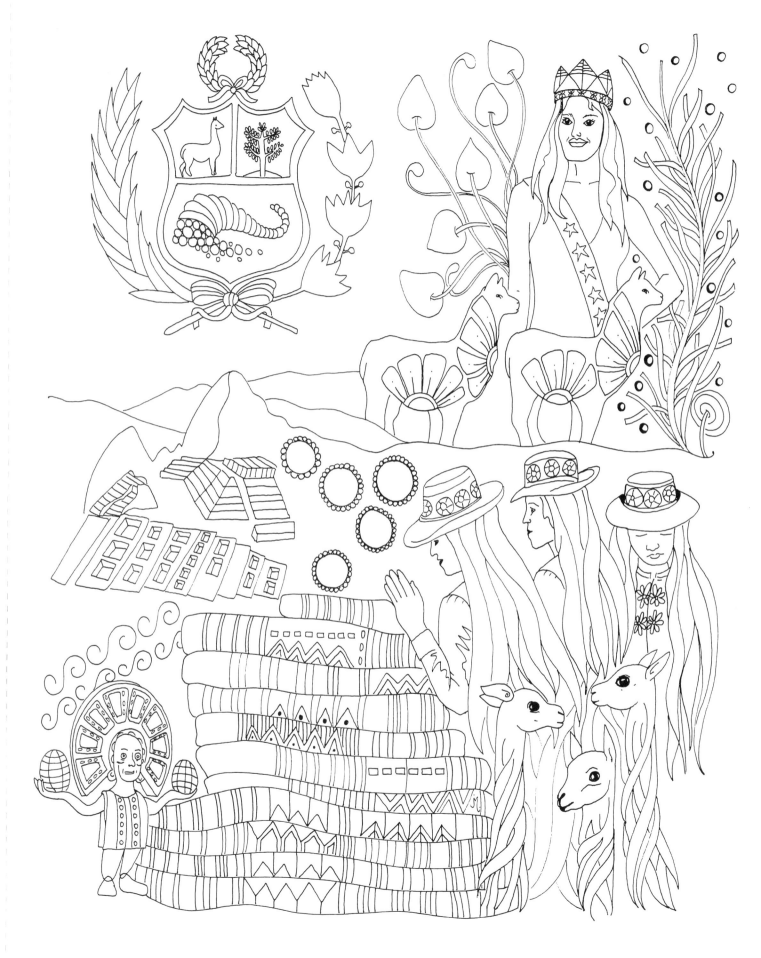

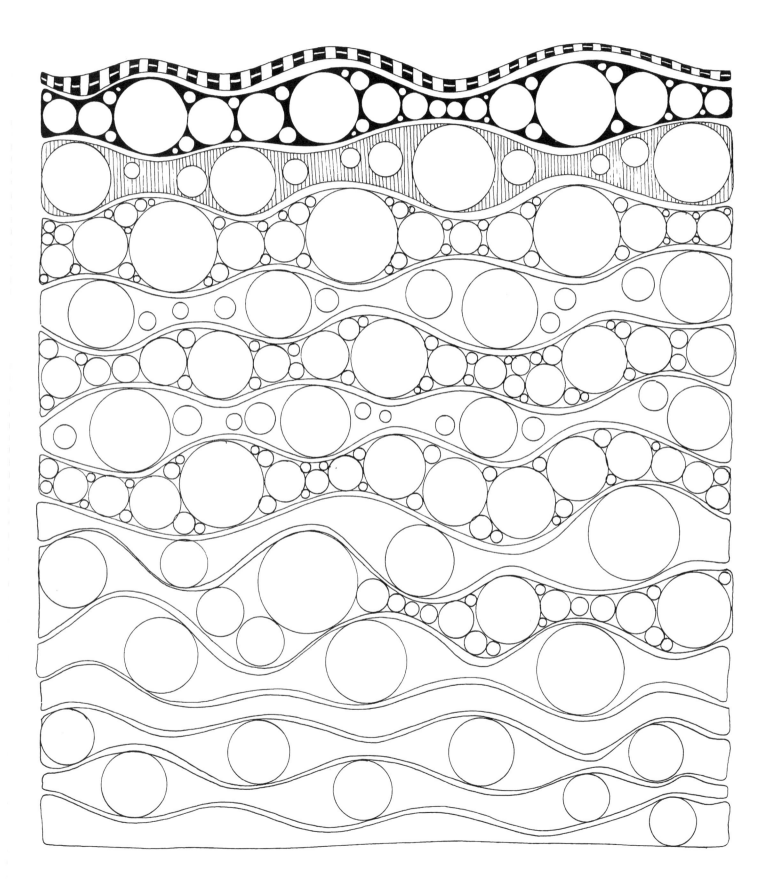

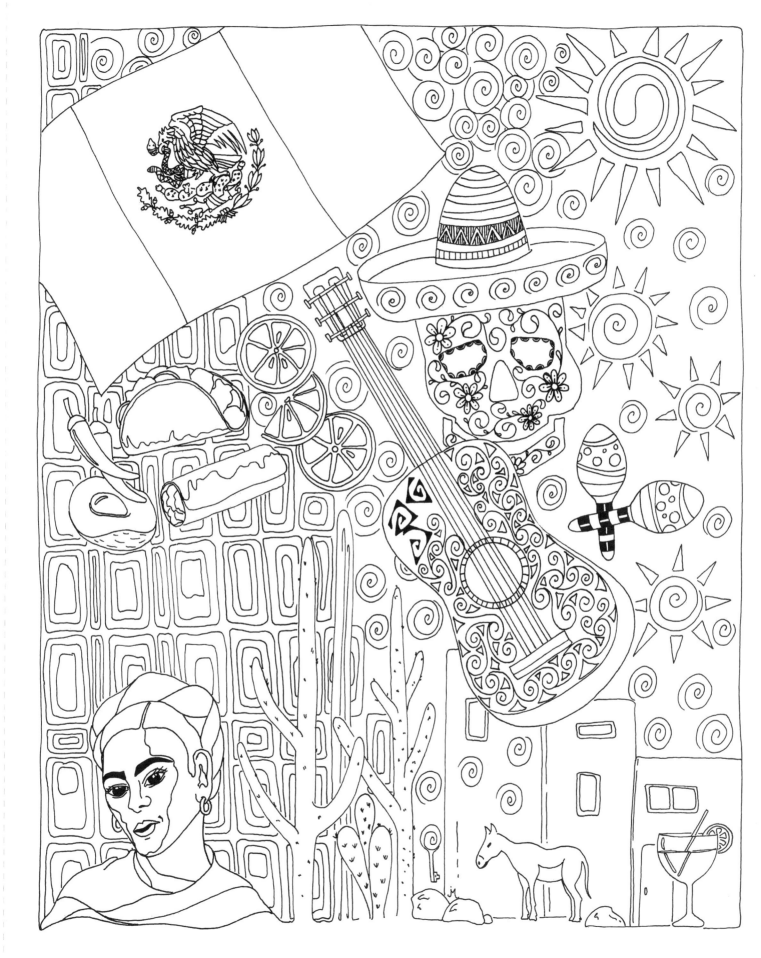

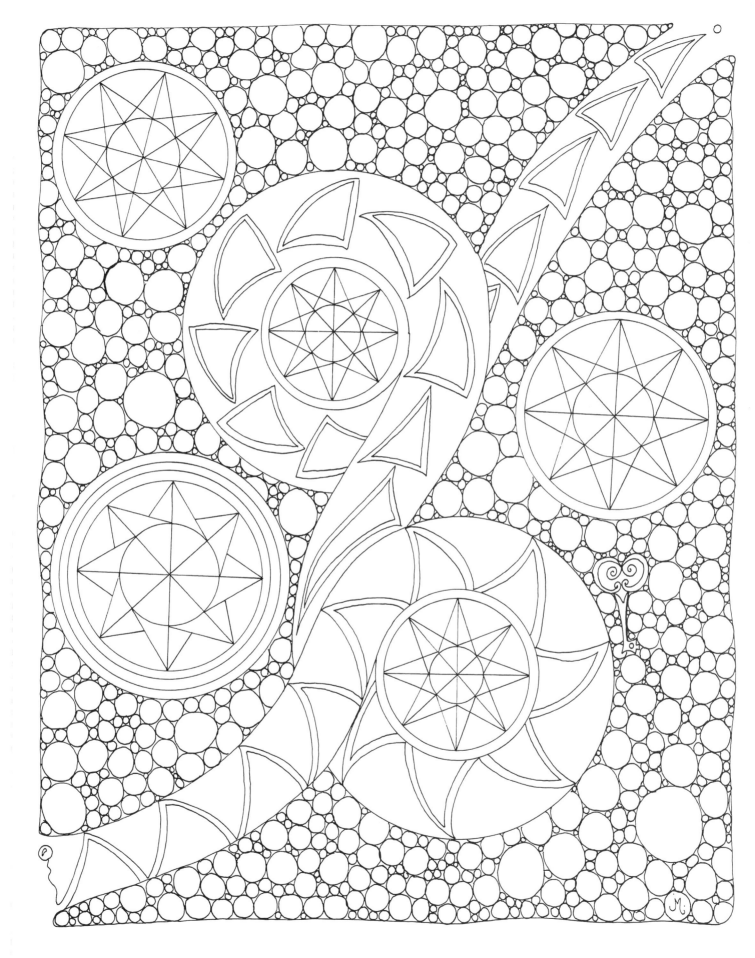

Fill the map with tangle patterns. See the corresponding example inside the front cover.

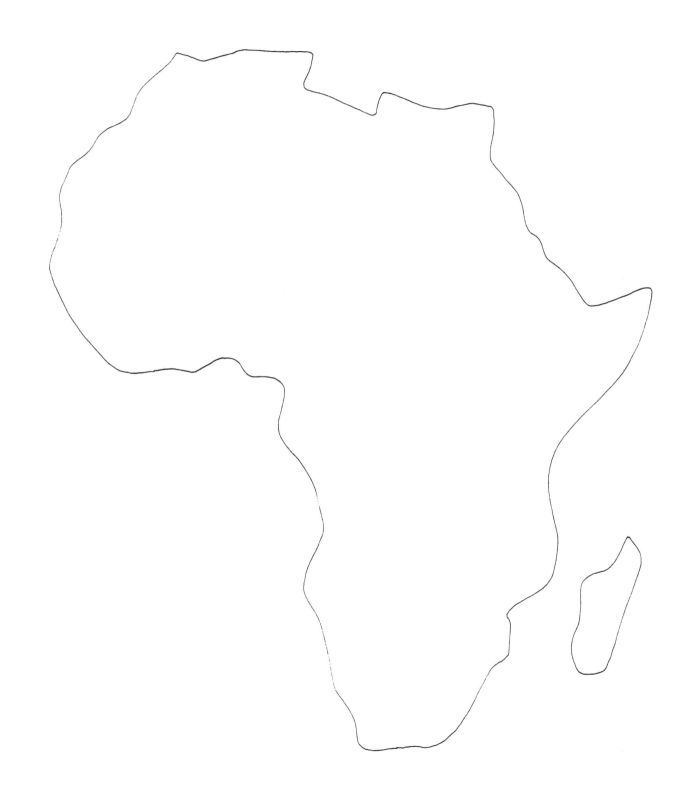

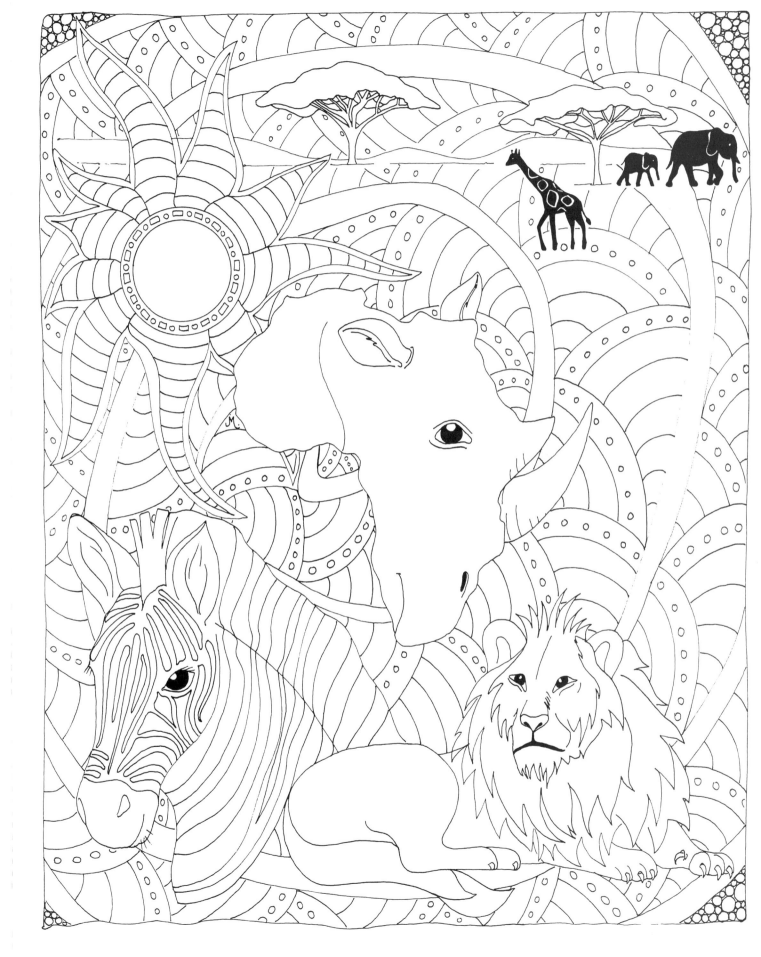

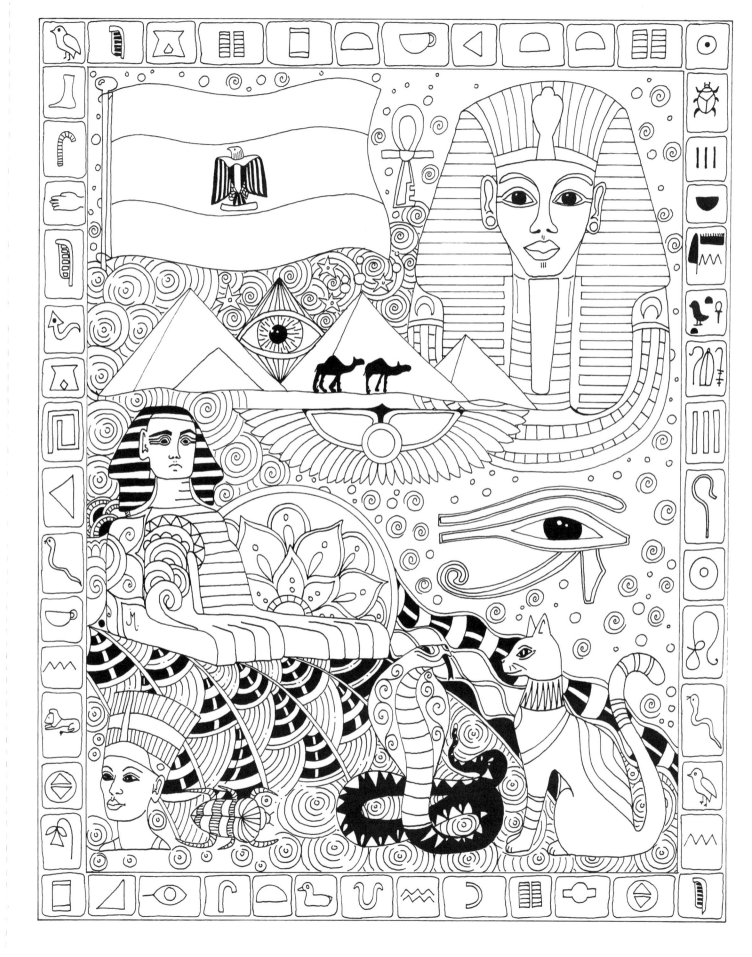

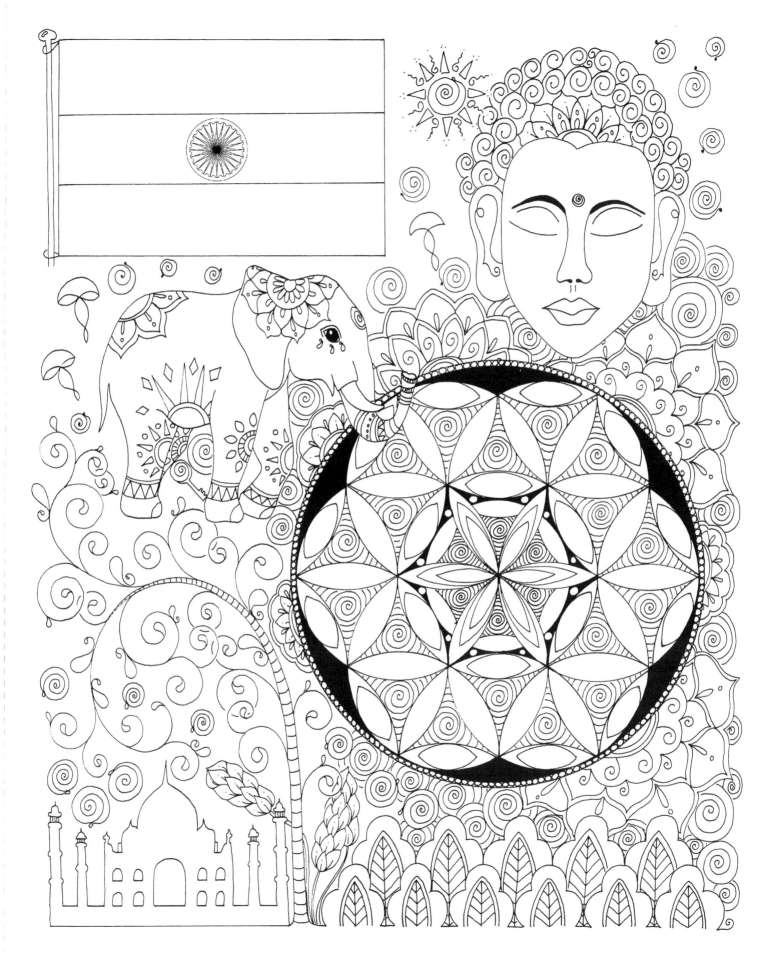

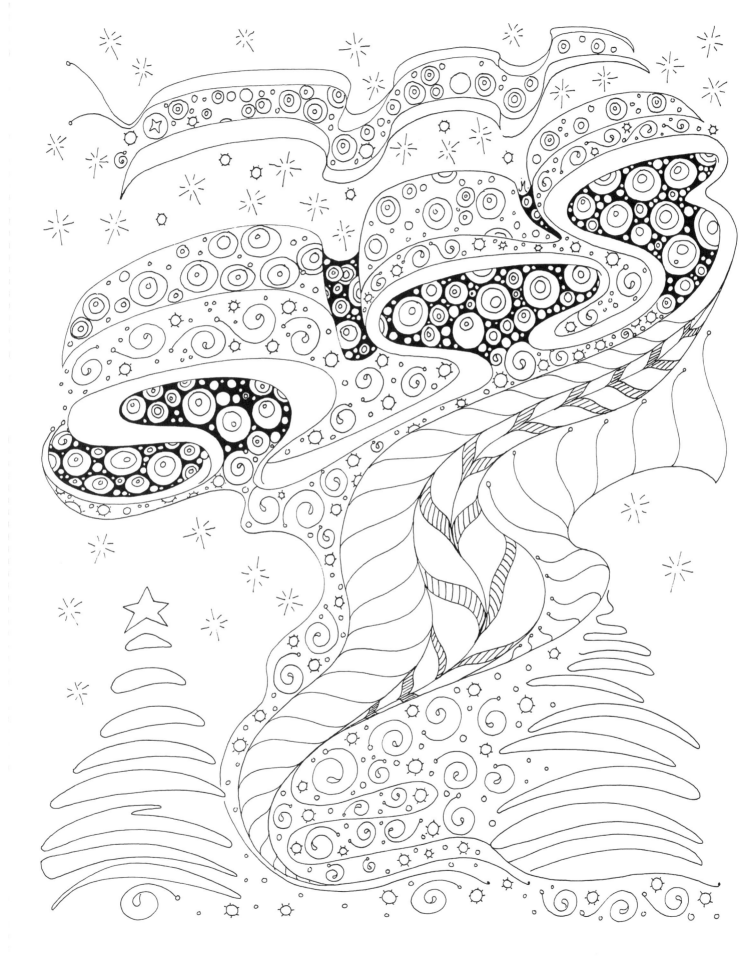

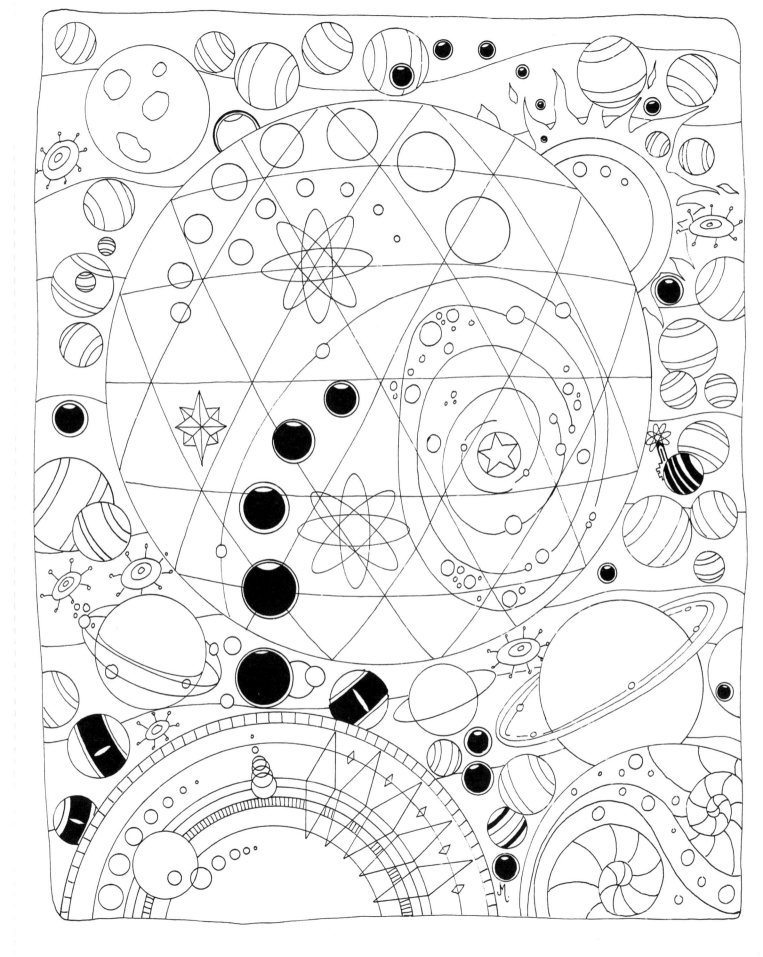

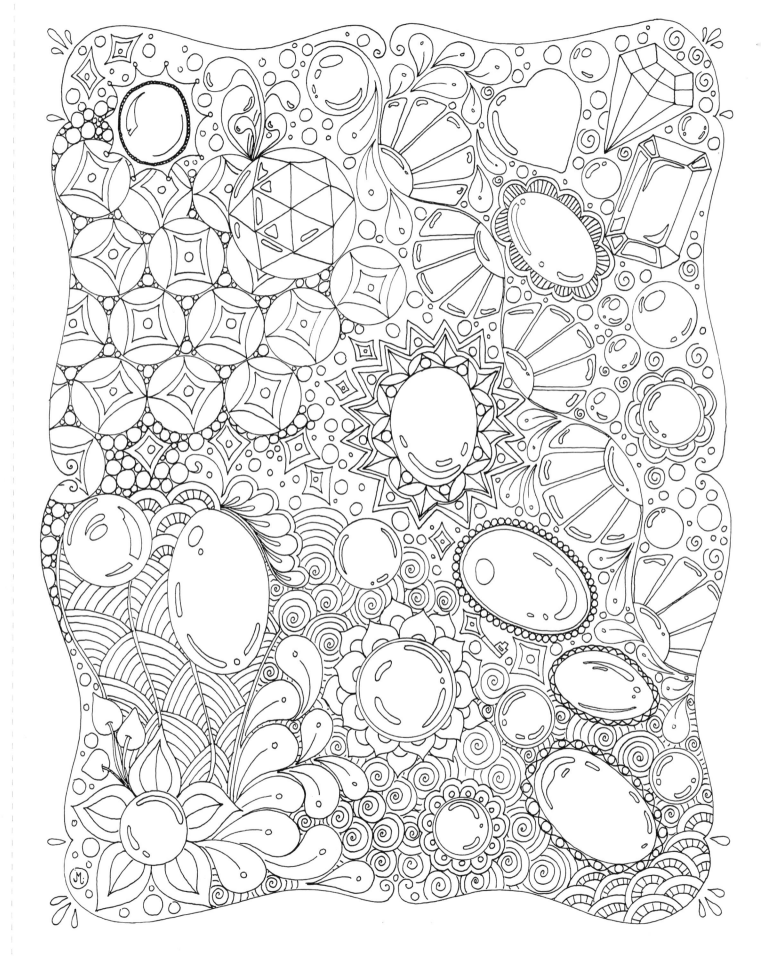

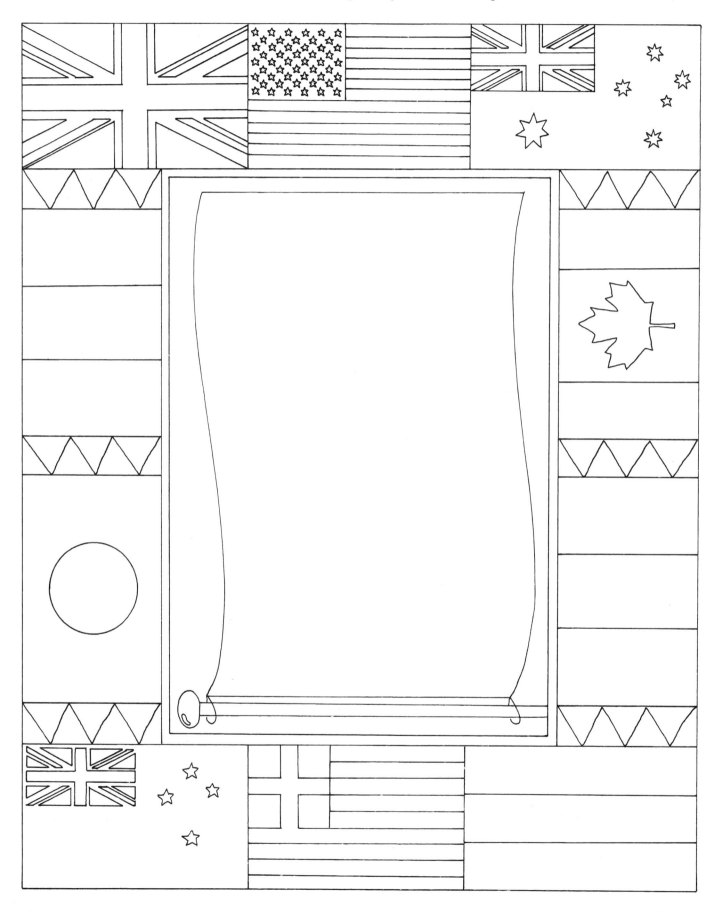

Write in the name of your favorite destinations onto each travel tag. They make great bookmarks.

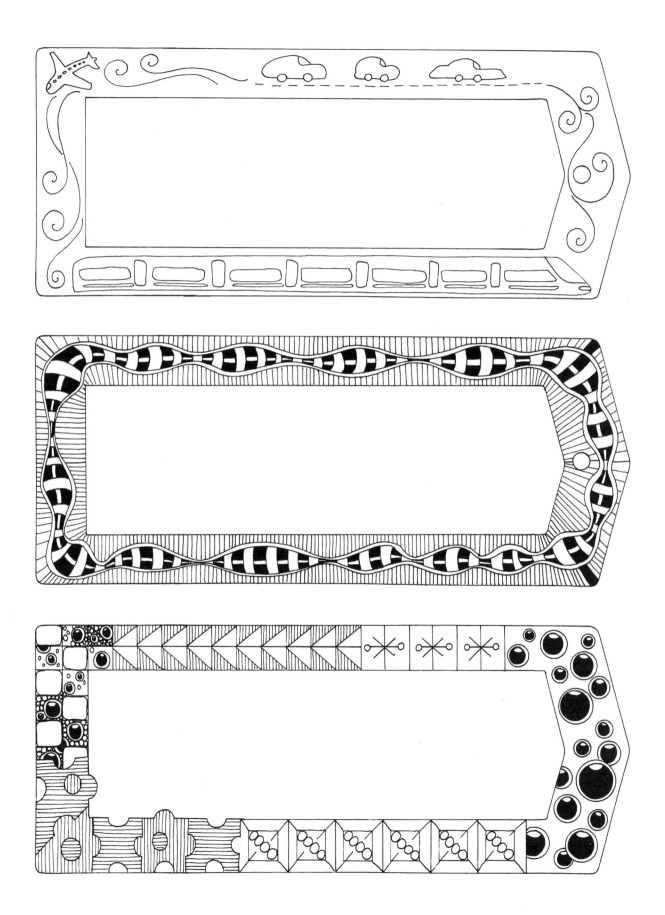

TECHNIQUE TRY OUTS

Use these sample pages to practice tangle patterns and border patterns, and experiment with different mediums and color combinations.

RESOURCES

Faber-Castell
www.fabercastell.com
Polychromos Pencils

Zentangle
www.zentangle.com
www.zentangle.blogspot.com

ABOUT THE AUTHOR

Jane Monk lives in Tasmania, Australia, with her husband James, son Jonathan, and three cats, Shadow, Merlin, and Jet. She is a self-taught artist who has been drawing since she was a young girl, inspired by the beauty in all things in the natural and man-made worlds. Patterns and repetition, the sometimes quirky and different, are what inspire her work. Drawing is Jane's first love and something she is compelled to do every day. Jane became a Certified Zentangle Teacher in Class #4 in October 2010.

Website: www.janemonkstudio.com
Blog: www.janemonkstudio.blogspot.com
Email: jane@janemonkstudio.com

Quarto is the authority on a wide range of topics.

Quarto educates, entertains and enriches the lives of
our readers—enthusiasts and lovers of hands-on living.

www.QuartoKnows.com

First published in the United States of America in 2016 by
Creative Publishing international, an imprint of
Quarto Publishing Group USA Inc.
400 First Avenue North
Suite 400
Minneapolis, MN 55401
1-800-328-3895
QuartoKnows.com
Visit our blogs at QuartoKnows.com

10 9 8 7 6 5 4 3 2 1

ISBN: 978-1-58923-941-8

Book Design: Leigh Ring // www.ringartdesign.com
Cover Image: Jane Monk
Cover Design: Leigh Ring // www.ringartdesign.com

Printed in China

The Zentangle® art form and method was created by Rick Roberts and Maria Thomas. "Zentangle" is a
trademark of Zentangle, Inc. Learn more at www.zentangle.com.